In Search
of Eternity

Published in conjunction with the exhibition "TIMELESS WONDER. PAINTING ON STONE IN ROME IN THE CINQUECENTO AND SEICENTO"
October 25, 2022 – January 29, 2023
Rome, Galleria Borghese

OFFICINA LIBRARIA

via dei Villini 10
00161 Rome
www.officinalibraria.net

Art Direction and Lay-out
Paola Gallerani

Translations
NTL, Florence

Editing
Wendy Keebler

Image acquisitions and permissions
Matilde Fracchiolla

Color Separation
Premani, Pantigliate (MI)

Printing and Binding
Petruzzi Stampa, Città di Castello (PG)

Press Office
Luana Solla

isbn: 978-88-3367-209-0
© Officina Libraria, Rome, 2022
www.officinalibraria.net
Printed in Italy

In Search of Eternity

PAINTING ON AND WITH STONE IN ROME
itinerary

Edited by
Francesca Cappelletti and Patrizia Cavazzini

OFFICINA
LIBRARIA

Contents

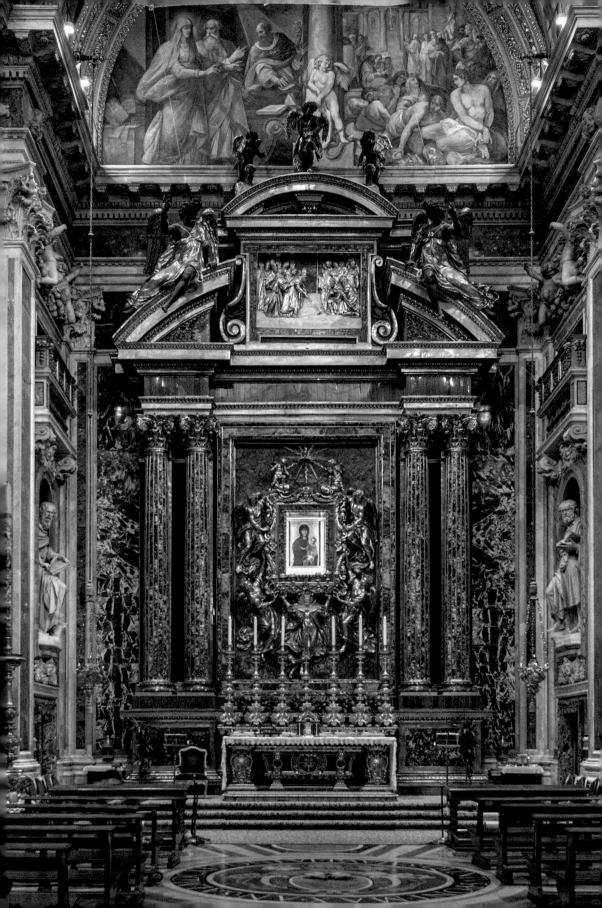

In Search of Hidden Stone

Francesca Cappelletti

This guide, which offers an original itinerary taking in a number of churches and palaces in Rome, is associated with the *Timeless Wonder: Painting on Stone in Rome in the cinquecento and seicento* exhibition running at the Galleria Borghese from October 25, 2022, to January 29, 2023. It is the second in a series of experiments designed to give wider resonance to the research carried out during the preparation of the show, one that extends beyond the confines of the museum and the circumscribed time frame of the exhibition. The itinerary about Guido Reni in Rome, published last spring, took visitors to the *Guido Reni at Roma: Nature and Devotion* retrospective on a long trail outside the exhibition rooms, tracing his whole career and building up a picture of the success of his style. Indeed, he continued to find settings for his works even after his first crucial sojourn in the city.

This volume is no less important, acting as a guide to often little-known works in churches that are not always open. Some of them will be opening during the exhibition run, and the photos taken for the occasion will provide an opportunity to get to know and study them in the future, even if the places where they are housed continue to be hard to access.

The publication of this itinerary is therefore a way of putting the process of discovery into print, of remembering the amazement it provoked and linking it to specific places. Visitors to the exhibition will realize the extent to which stone was a highly prized material among painters and their clients, especially in the second half of the sixteenth century and the first three decades of the seventeenth. Not only was there a proliferation of works—sometimes rare, often brightly colored, and invariably polished—destined for private collections, but many altarpieces, on slate and, less frequently, peperino, were also commissioned. Their weight is such that they cannot be moved, so to see them, it is necessary to go to the churches or palace chapels where they are housed. Setting out on our search, then, we can start in the place where the whole story began, in Santa Maria del Popolo, finally observing the painting of Sebastiano del Piombo, the celebrated inventor of a painting technique associated with the desire to create works that are "almost eternal."

The unfolding itinerary confirms that other concerns and ambitions also lay behind this practice and its success. The wish to revive one of the most highly appreciated ancient techniques, to exploit the shininess of stone, and to adopt a new method for producing altarpieces must be considered to have been among the aspirations of at least two generations of painters, who continued to experiment and to demonstrate their virtuosity, drawing on Michelangelo and Raphael as examples. In their works, paint covers the support, hiding it and making it secret. Exercising great technical ability and concealing it at the same time is one of the characteristics shared by the sixteenth-century artists rediscovered in this guide. Masters ranging from Francesco Salviati to Taddeo and Federico Zuccari, among others, built their fame on a capacity to tackle different materials and working environments and not to place any limits on invention. We can analyze, subdivide, and articulate the concept of mannerism and Counter-

Reformation art, definitions that struggle to hold together different decades and personalities, but in the second half of the sixteenth century in Rome, the use of stone as a support for painting was also part of a repertoire of ideas and experimentation that coincides to a large extent with the patronage of the Farnese family.

This journey exploring the most significant sites for painted stone in Rome could not neglect to include some examples of altars that have not been painted but have been decorated with colored marbles instead. This tendency parallels the propensity, highlighted in the exhibition, to paint not *on* stone but *with* stone, exploiting its shades of color. This trend rarely extends beyond the beginning of the seventeenth century, though colored marbles did continue to be arranged in patterns around altarpieces. We could go further in our reflections and consider the substitution of painting with sculptural altarpieces, which told stories through the idiom of large-scale white sculpture, as occurred in the middle of the seventeenth century, especially at the time of the patronage of Camillo Pamphilj.

This guide stops before that, concentrating on stone and its relationship with painting and color. It will enable ideas to circulate during and long after the end of the exhibition.

Introduction

Patrizia Cavazzini

The *Timeless Wonder* exhibition at the Borghese Gallery is devoted to paintings on stone produced for the most part in Rome and Florence between 1530 and 1650, a period spanning the emergence of this technique and its eventual decline in popularity. With the exception of Francesco Albani's *Madonna and Child with Two Angels* from the Capitoline Museums, the paintings are of modest or very small dimensions and would originally have been hung on walls, placed on side tables, kept in small boxes, used as pendants for necklaces, or inserted into reliquaries and furniture. But painting on stone was not restricted to this scale. Indeed, many altarpieces were painted on stone supports in Rome—and almost exclusively here—between 1530 and 1614, generally on *lavagna*, a dark slate extracted in an area near Genoa, which was also used in ancient Rome. Peperino, a local stone, was used more rarely. It is not possible to transport the altarpieces—they can be up to nine meters high and weigh hundreds of kilograms—and so showing them in an exhibition is inconceivable. They are made up of slabs—which are bigger and thicker in the lower section—with joins between them that have inevitably deteriorated over time. They are not obviously distinguishable from altarpieces on panel, because the polished effect is similar and the pictorial film often covers the whole support, masking its leaden shades. The itinerary lists many, though not all, of the ones existing in Rome and includes works of difficult or impossible access, the hope being that what we cannot visit today we will be able to visit in the future.

The practice of painting on a stone support with oil was initiated by Sebastiano Luciani, known as Sebastiano del Piombo. After coming to Rome from Venice in 1511 at the invitation of the wealthy banker Agostino Chigi, the painter immediately found himself having to use the fresco technique in the Villa Farnesina, where his work would have vied with that of Raphael. With little expertise in the technique and dissatisfied with the chromatic limitations of fresco pigments, Sebastiano soon began trying out methods for using oil on wall surfaces, as did Raphael. The *Flagellation* in the Borgherini Chapel in San Pietro in Montorio, executed in oil on stucco and completed in 1524, attests to an initial success in this field (itin. 19). His *Portrait of Andrea Doria* on slate at the Galleria Doria-Pamphilj suggests that Sebastiano had already developed the technique of oil painting on stone before the Sack of Rome in 1527, and he was certainly aware that he was reviving an ancient practice cited by Pliny. But it must have been the devastation caused by the traumatic events of the Sack that led to the increasing popularity of painting on stone. Painters working in the city, and even more so their clients, were under the illusion that stone conferred immortality on painting. When it eventually became clear that this was not the case, the vogue for painting altarpieces on slate died out.

In Rome, abandoning the use of panel as a support and introducing canvas took place much later than in Venice, perhaps in part for aesthetic reasons but also because canvas was regarded as particularly fragile. The greater susceptibility to deterioration of painting compared with sculpture was, in fact, considered a disadvantage in the debate over the relative merits of the two visual arts. Until the mid-sixteenth century, canvas was used above all for standards, which

had a short life span, for paintings that would be shipped outside Rome, and sometimes for portraits. It may have been Girolamo Muziano, from Veneto, who contributed significantly to its spread to Rome, and it is possible that a significant event for its adoption was the showing of his large *Resurrection of Lazarus*. Measuring 295 × 440 cm and executed in 1555, it is now in the Pinacoteca Vaticana. Before 1564, it was put on display in Palazzo Venezia, attracting enormous admiration, including from Michelangelo, and after Muziano's death, it was used to adorn his tomb in Sant Maria Maggiore. Among the most significant altarpieces of the late sixteenth century were two works on canvas by Federico Barocci in the Chiesa Nuova, the *Visitation* and the *Presentation of the Virgin in the Temple*, with the material being chosen also to solve the problem of transporting the works from Urbino. But many were on different surfaces, and canvas was still not universally employed around 1600. The type of support was generally specified in the contract and tended to be chosen by the client. Cardinal Alessandro Farnese (Paul III's grandson) and his circle, for instance, were extremely reluctant to adopt canvas for altarpieces, often preferring panel or slate.

The almost hundred-year period covering the history of altarpieces painted on stone began in 1530 with the *Nativity of the Virgin* by Sebastiano in the Chigi Chapel in Santa Maria del Popolo, a painting that was according to Vasari, completed by Francesco Salviati (itin. 1). Rich in polychrome marbles, the chapel had been designed by Raphael as an imitation of the Pantheon, to be used as a burial place for Agostino Chigi. Only after the death of Raphael and the client in 1520 did Sebastiano become involved. An altarpiece on stone was certainly not in the original plan, but this was the ideal place for highlighting the symbolic meanings of the material. The marbles of pagan Rome that had survived down the centuries were adapted here to a Christian use, with the aim of rendering the patron's memory and fame eternal. Painting on stone met the same requirement. In chapels, it is sometimes found together with paintings on copper or other metals, materials that were considered similarly everlasting. Totally forgoing the use of painting in a chapel also often indicated a desire to make the memory and name of a noble house eternal, as in the case of the Caetani Chapel in Santa Pudenziana (itin. 15). In the sumptuous Ginetti Chapel in Sant'Andrea della Valle the family squandered a large part of its wealth on its marbles when it became clear that their line would become extinct. There was no painting in the chapel at all; the altarpiece was a bas-relief by Antonio Raggi, and even the clouds in the lantern of the dome were created with inlays of alabaster.

Although the reuse of marble from excavations was very widespread in late-sixteenth-century Rome, it should be noted that altarpieces on stone supports were often made for chapels where marble was abundantly used, in order to emphasize the antiquarian interests and the magnificence of the client. For those who considered the cost excessive, there was always the possibility of imitating marble, as in the case of the painted *giallo* and *verde antico* around the altarpiece of Saint Barbara in Santa Maria dell'Anima (itin. 3).

The robustness of the stone material in altarpieces was sometimes used to allude to the solidity of the Catholic church—based on the faith of the early martyrs and on Christ's words to the apostle Peter, "you are Peter, the Rock; and on this rock I will build my church" (Matthew 16:18)—a notion reaffirmed both when the advance of Protestantism seemed unstoppable and when the threat receded. The apogee of these concepts was the series of altarpieces on slate devoted to episodes from the life of Peter, conceived for Saint Peter's Basilica on the occasion of the Jubilee of 1600. The six paintings formed a ring around the saint's tomb, emphasizing the role of mausoleum intended for the new church by Clement VIII. However, the works quickly deteriorated due to the dampness of the location, proving unequivocally that the eternity of painting on stone was just a mirage, nothing more than a rhetorical artifice. It is no accident that from then on, the practice of painting on slate came to an abrupt halt. On the other hand,

the custom of placing circular or oval portraits on slate in funerary monuments, clearly with the intent to perpetuate the memory of the deceased, continued right through until the nineteenth century (itin. 10).

Chronologically, the final examples of painting on stone in a Roman church were the four saints by Lavinia Fontana, set into the marble pillars at the entrance to the Rivaldi Chapel in Santa Maria della Pace in 1614, produced shortly before the Bolognese painter's death (itin. 4). Fontana was the only woman of her time to obtain public commissions in Rome; her reputation is proven by the fact that she would have been paid as much as her male colleagues for the lost *Stoning of Saint Stephen* for San Paolo Fuori le Mura if it had been deemed to be of the same quality as those by her peers. Perhaps due to their envy, her work did not meet with great favor on this occasion, but this did not close doors for her in Rome. In the main chapel of Santa Maria della Pace, the notary Gaspare Rivaldi gave her the job of producing both the saints on slate and the funerary portraits of himself and his wife on a material similar to aluminum. As can be seen in the paintings on display in the exhibition, from the outset, the typical meanings attributed to touchstone were sometimes associated with slate. Indeed, it was thought that touchstone could reveal the authenticity and value of gold and, by analogy, truth in general and the ability of an artist. Fontana's contributions to the chapel also perpetuate her memory, in addition to that of the clients, demonstrating her abilities despite the setback at San Paolo.

Chigi Chapel

- Sebastiano del Piombo, *Nativity of the Virgin*, oil on peperino stone, 1530–1547

Following Raphael's death on April 6, 1520, work on the splendid funerary chapel of Agostino Chigi—the pope's banker—in Santa Maria del Popolo came to a halt. Raphael's design, inspired by the Pantheon and in line with Donato Bramante's novel features for Saint Peter's, envisaged a central plan, magnificent mosaics in the cupola (with the figure of God the Father, the mover of heaven and earth), the tomb of Agostino and his wife along the side walls, rendered eternal by the creation of pyramids made with precious marbles, and an *Assumption of the Virgin* for the altar. However, this last part of the project remained on paper.

In 1526, Filippo Sergardi, the executor of Chigi's will, gave the commission for the chapel altarpiece to Sebastiano Luciani, who would only became known as Sebastiano del Piombo when Pope Clement VII made him keeper of the papal seal (*piombatore apostolico*, hence his nickname). Though Raphael's original plan was for an *Assumption*, the subject was altered to a *Nativity of the Virgin* to fit in with the dedication of the altar and to celebrate the Immaculate Conception, necessary condition for the Assumption of the Virgin Mary. Alluding to this doctrinal theme, at the center of religious debate at the time, is the eternal God in the upper part of the altarpiece, who is exempting Mary from the original sin, surrounded by a court of wingless angels laying out the scriptures to demonstrate the purity of the Mother of God.

Imagine what it must have meant for the Venetian painter to take over from his great rival Raphael. Just a few months earlier, following a commission from Cardinal Giulio de' Medici, he had competed with Raphael to produce an altarpiece for Narbonne Cathedral—his *Raising of Lazarus* (National Gallery, London), made with the help of Michelangelo, against Raphael's *Transfiguration* (Pinacoteca Vaticana, Vatican City).

Painting for the Chigi Chapel meant that he once again had to measure up to and engage with Raphael's marvelous creations, adopting a grand register and an equally Classical idiom. Sebastiano rose to the challenge. Not only did he conceive a work that was on an even more monumental scale than the original project, no less than 593 cm high, but he also discovered and patented a new technique for painting on stone. This enabled him to emerge victorious from the *paragone* between painting and sculpture, conferring on paintings the same immortal destiny as statuary.

The amazing novelty of the work was noted by contemporaries, who praised it in enthusiastic tones. Cardinal Vittore Soranzo, in a letter from Rome to Pietro Bembo on June 8, 1530, wrote: "Sebastianello, our [fellow] Venetian, has discovered a beautiful secret for painting on marble with oil, painting which will be little less than eternal. The moment the colors dry, they unite with the marble in a manner that is almost petrified. He has done every test and it is durable." Less than two months later, on August 1, 1530, Sebastiano signed the new contract for the Chigi altarpiece, which reiterated the comparison with Raphael and highlighted the novelty of "eternal painting," specifying how the painter was to "paint the . . . altarpiece now built from peperino in the aforementioned chapel. It must be painted in oil in that new manner and invention which he, after great toil and experience, has acquired with all his ingenuity, and he must give it the perfection of which he is capable and which will make it comparable to every other altarpiece in Rome, and principally that of Raphael from Urbino in San Pietro in Montorio [the *Transfiguration*]."

Sebastiano's stone altarpiece consists of overlapping rows of peperino, which replaced the original masonry, as can be seen outside the chapel, where the facing protrudes by a few centi-

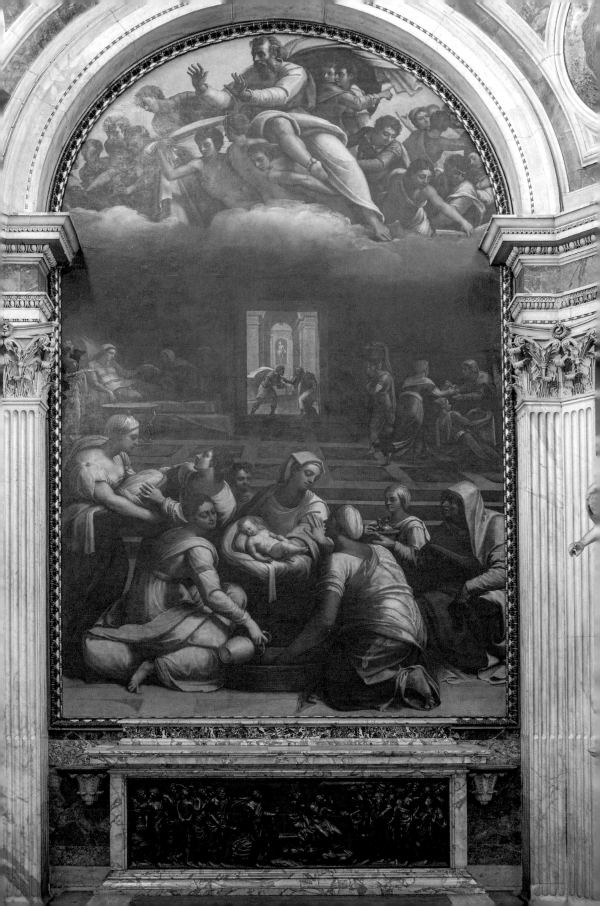

meters from the original line of the construction. Besides the altarpiece, Sebastiano was also to have painted, in oil on brick (a material lighter than peperino and therefore preferable for structural reasons), the four tondos with the seasons in the pendentives and the eight panels in the drum of the cupola with scenes from Genesis, which were realized after his death by Francesco Salviati.

The revolution in technique was carefully reported by Giorgio Vasari, who credited Sebastiano with having invented painting on stone, where the support was treated with a "mix of Greek pitch and resin and thick varnish [which has been] boiled." This was applied "with a big brush" and spread "with a builder's trowel heated in the fire." Using the same mixture and keeping the colors intact, Sebastiano painted various materials besides slate and brick—"peperino, marbles, mixed stones, porphyries, and very hard slabs of stone, on which the painting can last for a very long time"—giving rise to a very successful genre of painting.

Costanza Barbieri

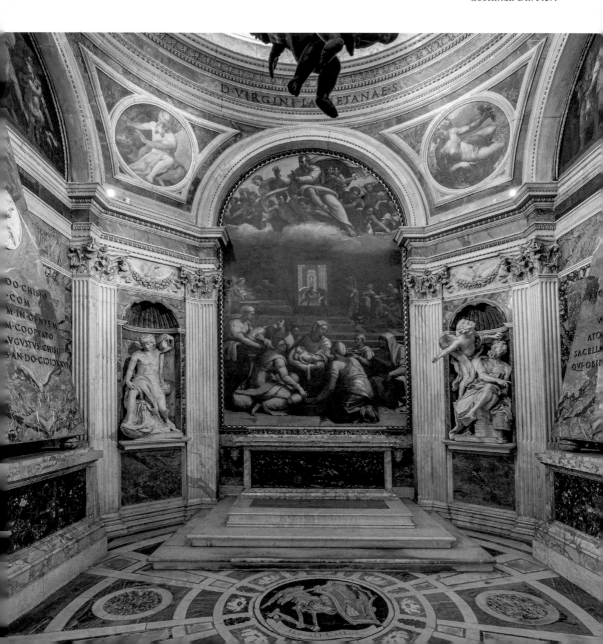

2. SANT'AGOSTINO

Mutini Chapel

- Marcello Venusti, *The Martyrdom of Saint Catherine of Alexandria*, oil on slate, 1550–1553

Upon entering the church of Sant'Agostino in Campo Marzio, the chapel dedicated to Saint Catherine of Alexandria is the first on the right. Above the chapel's marble altar, the central section of the altarpiece depicting the titular saint at prayer, surrounded by pieces of the wheel of her martyrdom destroyed by divine intervention, is painted on slate surrounded by rich decoration in stucco and gold. The smaller rectangles to the sides represent Saint Stephen (left) and Saint Lawrence (right), on paper presumably glued to slate.

Sources, starting with Gaspare Celio (1638), attribute the entire decoration to Marcello Venusti, an artist from the Valtellina, who was commissioned to carry out the work by the Mutini family. The patronage of the chapel passed to the Gottifredi family in the eighteenth century, as indicated by a stone plaque dated 1725. It was probably at this time that the Mutini coat of arms was retouched. The other painted decorations on each side of the altar, such as the angels above the sepulchral monuments of Stefano and Lorenzo Mutini, date to the nineteenth century, as do the three Virtues in the tondos of the flattened dome.

The Mutini, who originally came from Liguria before moving to Rome, were generals in the papal fleet and allied with the Parentucelli and Della Rovere families. A marble plaque on the right wall of the chapel commemorates the most important family members, starting with

Stefano Mutini, a knight of Saint James and the father of Ettore, who married Clementia Leni in 1533. From their union came Stefano (d. 1585), the husband of Clementia Caffarelli, Caterina (d. 1555), and Lorenzo (still alive in 1609). The iconography of the decoration evidently reflected a desire to celebrate the patron saints of the family. However, in the Augustinian church of San Trifone in Posterula that preceded the foundation of Sant'Agostino, there was already a chapel dedicated to Saint Catherine, established by the Vivalti family. When the new church was built, it may have been decided to respect the original structure, retaining the names of the old chapels.

In the records of the Augustinians, held in Rome's state archives, there is evidence to suggest that Ettore Mutini donated a large quantity of grain in 1553 as partial payment for the officiation of the chapel; it is therefore likely that it had already been decorated by Venusti by then. The dating would also explain the resemblance between Venusti's

style and the manner of Perino del Vaga (who had died only a few years previously but with whom the artist had established strong professional dealings while working for the Farnese), above all in the depiction of the angels holding the saint's crown. They appear to be modeled on the announcing angel painted by Perino in the Pucci Chapel in Trinità dei Monti. The two angels in the Sant'Agostino altarpiece seem to differ greatly, though: the one on the right is more developed than the one on the left, which has a flattened and less refined profile, probably because it was repainted at a later date. The image of the saint conceived by Venusti was an enormous success, spawning numerous drawings (one belonged to the connoisseur and collector Father Sebastiano Resta) and copies painted by other artists. One of these is now in the monastery of Santa Caterina dei Funari in Rome, and another is in the sanctuary of the Madonna del Sasso in Bibbiena. There are also other versions in Spain. But the depiction of the saint in Sant'Agostino is the only one painted on slate. This kind of support was chosen by other important families of the age to decorate their altars and reflects the desire of the Mutini family to maintain a prominent role among the city's nobility. At the same time, it demonstrates Venusti's ability to follow in the footsteps of Sebastiano del Piombo, who had died in 1547 but was still the main point of reference in Rome when it came to using slate as a support.

Francesca Parrilla

Chapel of Saint Barbara

● Michiel Coxcie, *Saint Barbara, with Cardinal Willem Enckenvoirt and the Trinity,* oil on peperino stone, 1531–1534

The altarpiece of the Chapel of Saint Barbara, the third on the left of the nave of Santa Maria dell'Anima, is the earliest of the large-scale altarpieces on a slate surface in Rome to be completed. It has recently been claimed that it was, in fact, painted on plaster, but close personal examination proves that it is indeed painted on a surface of peperino stone blocks—and the poor state of preservation offers proof of that.

The chapel was home to the confraternity of Saint Barbara, a saint whose devotion was particularly popular in the German-speaking lands as the patron saint of miners, and Santa Maria dell'Anima has been the German church in Rome since the fifteenth century. After the return of the popes to Rome, each foreign nation gradually took over a church in the city for the worship and support of their compatriots. This particular commission was the responsibility, according to Giorgio Vasari, of the powerful Cardinal Willem Enckenvoirt, confidant of Pope Adrian VI; both men were from Utrecht, which was at this time an independent archbishopric and was treated as part of the German nation. The commission was given to Sebastiano del Piombo at some point in the 1520s, after Pope Adrian's death in 1523, but was never completed or even begun. Here, according to Vasari, Sebastiano toyed with the cardinal, "putting him off from one day to the next." It would appear, however, that at least the stone blocks for the surface of the altarpiece were Sebastiano's doing and that their placement may even be contemporary with those in the Chigi Chapel, as well as the substantial aedicule frame.

The altarpiece had to be completed later by Michiel Coxcie from Mechelen, known even to his contemporaries as the Flemish Raphael, who also completed the frescoes of the remainder of the chapel, between 1531 and 1534. Coxcie had been active in Rome from about the late 1520s, but this altarpiece is his only painting on stone, and he seems at first an unlikely choice to complete this project. As Santa Maria dell'Anima was the German church, there may have been a degree of *campanilismo* involved in the selection of Coxcie—indeed, it has even been speculated recently that Enckenvoirt had invited Coxcie to Rome specifically to work on this chapel for him.

The altarpiece shows Cardinal Enckenvoirt as a bulky elderly man with a flowing white beard dressed in his cardinal's robes kneeling before Saint Barbara. The saint is holding her martyr's palm with one hand and pointing to the cardinal with the other, while the Holy Trinity blesses the cardinal from the clouds above. Between the two figures is a charming view onto a landscape, with a prominent round Classical temple. This composition shows how fast Coxcie had been able to learn in Rome, as the composition is based on the *Madonna di Foligno* (Pinacoteca Vaticana, Vatican City) by Raphael, then in Santa Maria in Aracoeli.

Piers Baker-Bates

ALTARE
PRIVILEGIATVM

Rivaldi Chapel

- Lavinia Fontana, *Four Saints*, oil on slate, 1614

Visitors walking along the nave of the church of Santa Maria della Pace will come to an octagon known as the Templum Pacis. The oldest structure in the church complex, it was built in 1482 by Pope Sixtus IV (1471–1484) to house a fresco of the *Madonna of Virtue*. According to tradition, the image of the Virgin began to miraculously drip blood when stones were thrown at it. The work was on the wall of the ancient church of Sant'Andrea de Acquariciariis (eleventh century), before being incorporated into the west side of the new church. When

Innocent VIII (1484–1492) became pope, the nave was added to the pre-existing structure, and it was decided to move the holy image to the center of the octagon. This was not an ideal choice, but it was dictated by the size of the main chapel, which was too small for the marble tabernacle built to house the fifteenth-century fresco in a fitting manner.

It was not until 1611–1614, thanks to the generous intervention of Gaspare Rivaldi, that the main chapel was completely renewed. The perimeter of the church was enlarged into the adjacent street, and a new and extraordinary decorative program was undertaken to a design by Carlo Maderno (besides the architecture, he was also responsible for the marble inlays), with contributions from Francesco Albani in the vault, Domenico Cresti (known as Passignano) in the panels on the side walls, and, finally, Lavinia Fontana. As a result of these transformations, however, Sebastiano del Piombo's *Visitation* painted in oil on the wall in the old apse of the chapel was detached. The fragments were sold by the church's canons to Orazio Lancellotti in 1618; in 1803, they became part of the collection of Cardinal Joseph Fesch, Napoleon's uncle. Three of these fragments are

now in the duke of Northumberland's collection in Alnwick, England. It was the second unfortunate episode experienced by the painter in the church; according to Giorgio Vasari, the *Visitation*, painted in 1538, caused the canons a lot of trouble, as Sebastiano seemed unable to complete it, and the continued presence of scaffolding in the octagon prevented them from performing Mass in a satisfactory manner. Moreover, the artist did not paint the altarpiece of the chapel (the first one to the right of the nave) for Agostino Chigi; he was commissioned by Filippo Sergardi, the executor of the famous banker's will. According to sources, the support of the altarpiece, which Sebastiano never painted, was to have been in peperino, a natural stone of volcanic origin extracted only in certain areas of central Italy.

On the inner part of the two pillars flanking the entrance to the main chapel are four pieces of slate—aligned with the veined black marble of the facing—of identical dimensions, painted with oils by Fontana and already recorded in descriptions from the period, starting with Giulio Mancini (1623–1624), Pompilio Totti (1638) and Giovanni Baglione (1642).

The four saints (*Agnes*, *Cecilia*, *Catherine of Siena*, and *Clare*), with their iconographic attributes, were among the last works produced by the painter before her death in Rome in 1614. Emerging from dark backgrounds, the saints are looking toward the altar, with expressions that are infused with pathos and yet are mystical and passionate at the same time. Saint Agnes, her hands joined in prayer, is wearing a simple virginal tunic with very wide sleeves. Her facial features are those of a young girl devoted to chastity, and the figure of the lamb emphasizes Christ's sacrifice and prefigures that of her own personal martyrdom. Saint Cecilia, with a violin in her left hand and the organ behind her, is gazing languidly at the altar in a pose reminiscent of Raphael's saints. Fontana painted the elegant gown with particular care: a gold-colored dress embellished with drop pearls, transparent sleeves, and a slip with small floral motifs. Saint Catherine is engaging with the crucifix in her hand. The milk-white habit enveloped in a black cloak, typical of the Dominicans, emerges powerfully from the dark background of the slate surface; at her feet is a skull and some lilies that appear to have slipped down the folds of her habit to the ground. Finally, Saint Clare is the only one of the four

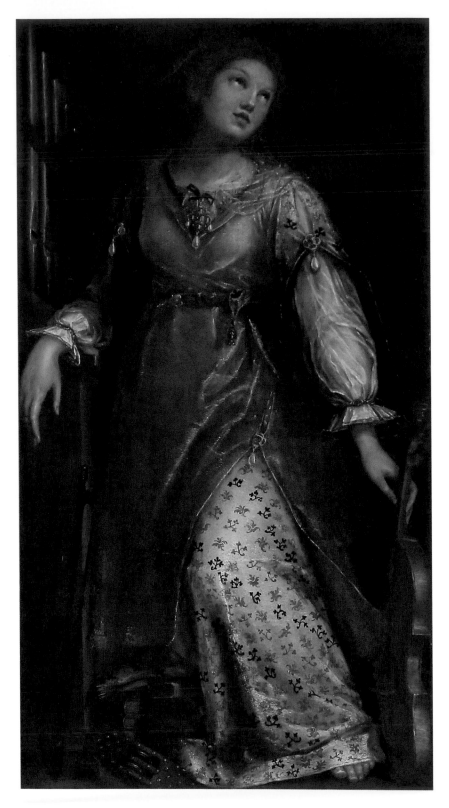

viewed totally in profile, kneeling in front of an altar and wearing a nun's dark gray habit; thanks to the construction of the volumetric planes and delicate touches of light painted on her gown, the saint is visible despite the darkness of the stone.

The significance of the saints' representation on the pillars of the nave is undoubtedly tied in with the culture of the Counter-Reformation, with exaltation of the saints of the ancient church (Agnes and Cecilia) being combined with a celebration of the orders of preachers and mendicants (Saint Catherine of Siena for the Dominicans, Saint Clare for the Franciscans). The patron, Rivaldi, is portrayed in an oval painted on aluminum situated on the left wall of the chapel, in front of a portrait of his wife, Ortensia Mazziotta, on the opposite wall. The two ovals are attributed to Fontana, who was also known for her skills as a portraitist, pointed out on various occasions by her biographers. In her portrait, Ortensia has the same decorative elegance as

the painted pearls found in the depiction of Saint Cecilia, and the expression on her face recalls some of the artist's other celebrated portraits.

Rivaldi, a notary, customs contractor, and holder of various offices in the papal government, must be credited for this fine example of late mannerist decoration, which has survived to the present day without any substantial alterations. Various techniques were used in the chapel, ranging from fresco to oil painting on wall and on slate, in addition to the richly decorated marble facing, executed using stones such as *giallo* and *verde antico*, portasanta, African red and gray, gray lumachella, alabaster, and, in the lobate cornice around the altar tabernacle, lapis lazuli and jasper, with a coherent aesthetic result.

Francesca Parrilla

Chapel of the Pallium

● Francesco Salviati, *Adoration of the Shepherds*, oil on peperino, 1548–1550

This *Adoration of the Shepherds* on peperino stone was painted by Francesco Salviati on commission from Cardinal Alessandro Farnese, vice chancellor of the Holy Roman Church. The vice chancellor was the most powerful papal official after the pope himself, and Cardinal Alessandro was also the grandson of the reigning pontiff, Paul III. Salviati, who had first arrived in Rome briefly in 1541, before moving permanently to the city in 1548, had rapidly become the preferred painter of the Farnese circle. Besides his official duties, Cardinal Alessandro was not only a leading patron of the arts in Rome but also particularly favored novel and innovative techniques. He was therefore to become arguably the most important proponent of the proliferation of large-scale altarpieces on a stone surface, implicitly recognizing their metaphorical quality. Salviati, in turn, would use his experience working for the Farnese as a launchpad for painting on a stone surface in the 1550s. That included, according to Giorgio Vasari, presiding after 1554 over the completion of the Chigi Chapel in Santa Maria del Popolo and in particular Sebastiano del Piombo's altarpiece on peperino (itin. 1). Sebastiano had only died in 1547, but he had been increasingly more inactive every year; the completion of the altarpiece involved Salviati not only in touching up the surface but also adding whole figures. Most sources since the seventeenth century have concurred in attributing to him the two female figures in the foreground of this altarpiece, an hypothesis that has now lost credit.

The location of Salviati's first foray into painting on a stone surface on his own account, the *Adoration of the Shepherds*, serves as the private chapel of the Palazzo della Cancelleria, which had been the official residence of the vice chancellor since 1517, and on whose decoration the artist worked between 1548 and 1550. This chapel was also a public space, as the curious name derives from the fact that for many years, it was where bishops and archbishops ceremonially received their mark of office, the *pallium*. Salviati's own practice on a stone surface did not develop until the 1550s; therefore, it can be assumed that the choice of the support here was that of Cardinal Alessandro, who had already demonstrated a predilection for such material experimentation.

Unfortunately, however, the altarpiece has deteriorated badly, and whole areas of the paint surface are now missing. In an almost square format, it shows the Adoration with the kneeling figure of the cardinal on the right-hand side and a young Saint John the Baptist in front of him. Saint Joseph is a portrait of Alessandro's grandfather, Paul III, who died in 1549 while work on the chapel was under way. The whole composition was evidently intended to be a glorification of the Farnese line, and it might include other portraits that are less easily recognizable today. Despite a perfect marriage between painter and patron here for the technique of painting on stone, it has been speculated by Clare Robertson that the *Adoration of the Shepherds* was not originally intended for the Chapel of the Pallium but that it was later adapted to fit the space. This hypothesis is supported by the fact that the altarpiece has been worked on in several stages. The figure of the cardinal is larger in scale than that of the others, while the head of the recently deceased pope is extremely clumsy. Furthermore, it has been grafted onto the body of an originally female figure, probably intended to represent Saint Elizabeth. Finally, the subject matter chosen fits awkwardly within the rest of the overall iconographic program of the chapel, while complex decorative programs were another

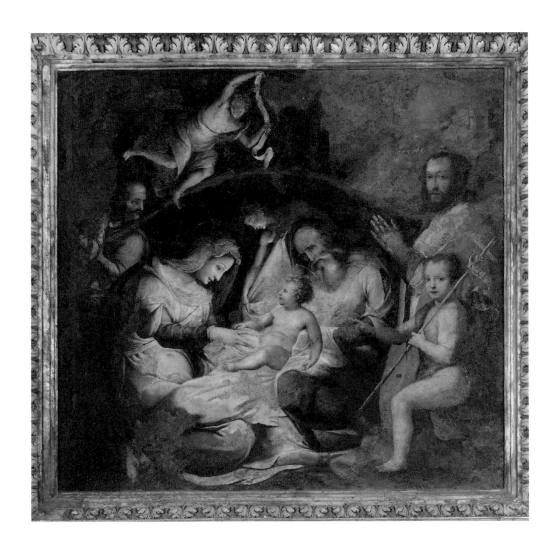

predilection of Farnese patronage. Nonetheless, in such a public space, this juxtaposition of the Holy Family with that of the Farnese would have immediately sent a deliberate and obvious message to the viewer.

Piers Baker-Bates

High Altar

- Taddeo and Federico Zuccari *The Coronation of the Virgin with the Martyrdom of Saint Lawrence and Saints Paul, Lawrence, Damasus, and Peter*, oil on slate, 1564–1568

This altarpiece represents a further and more public commission by Cardinal Alessandro Farnese for the high altar of his titular basilica, San Lorenzo in Damaso. The original structure of this ancient church had been demolished and incorporated within the fabric of the fifteenth-century palace, which was built between 1489 and 1513. In 1561, Pope Pius IV encouraged his cardinals to restore their titular churches, and Cardinal Alessandro's attention therefore turned from the palace itself to the basilica. Among much other work there, which has largely been replaced, he commissioned in 1564 a new high altar from Taddeo Zuccari, but the painter died two years later, and the commission was completed by his brother, Federico, between 1567 and 1568. The Zuccari brothers had succeeded Salviati as favored Farnese artists and were concurrently working on frescoing the cardinal's enormous villa at Caprarola, north of Rome. Fortunately, documents that have been recently found in the Farnese archive in Naples record the purchase of not only seventeen sheets of slate but also of light blue ultramarine pigments that Taddeo acquired through Stefano Dosio, confirming his personal participation at the outset of the project. It is worth reflecting here that, according to the same document, it cost a further 39 scudi just to have these slabs polished and mounted on the wall by a stonecutter named Marcantonio Buzzi, proof that painting on a stone surface instead of canvas was never the cheap option. And finally, in this same document, it is stated that the slate had been ordered specifically from Genoa. The Zuccari brothers had not only painted the high altarpiece but also completed the stucco cornice that surrounds it and forms an integral part of the composition—making it truly a multimedia work.

By April 1568, Cardinal Alessandro was being advised that the painting would be completed on his return from a visit to Sicily and that it would be "such a beautiful work that there will be nothing like it in Rome." The resulting altarpiece is indeed the largest ever completed on a slate surface, measuring no less than 8.93 × 3.97 meters. It consists of an unknown number of stone blocks—it is unclear whether the seventeen that were ordered in 1565 were sufficient—— although the joins are now becoming increasingly visible. Unfortunately, despite all the effort and although the bipartite scheme was originally derived from Raphael, the actual composition here is fussy and confused, being derived by Federico from a series of preliminary drawings by his deceased brother that he conflated for the final design. On the lower level are the kneeling Saints Lawrence and Damasus, with Saints Peter and Paul standing behind, all adoring the coronation of the Virgin, surrounded by angels in the second tier. Lawrence is the titular saint of the basilica, which was originally rebuilt by Pope Saint Damasus I, whose remains lie beneath the altar, while Peter and Paul, of course, are the foundations of papal authority. These four saints flank an image of Saint Lawrence being martyred on his gridiron. Current legibility or appreciation of this altarpiece is not helped either by the darkness of the surface, as it has never been cleaned, or by the stygian gloom of the basilica itself.

Piers Baker-Bates

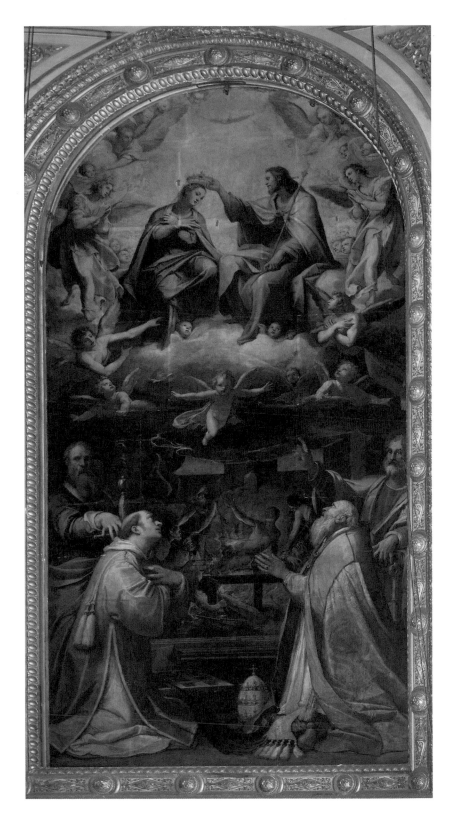

High Altar

- Peter Paul Rubens, *The Madonna della Vallicella Adored by Angels*; *Saints Gregory, Maurus, and Papias in Adoration of the Madonna della Vallicella*; *Saints Domitilla, Nereus, and Achilleus in Adoration of the Madonna della Vallicella*, oil on slate, 1608

The magnificent decoration of the high altar of Santa Maria della Vallicella, consisting of three giant altarpieces (left 429 × 263 cm; right 428 × 258 cm; center 464 × 280 cm), was executed by Peter Paul Rubens in less than a year, on slate supports made up of twelve slabs of slate for the lateral scenes and fifteen for the central one. The Marian theme centers on the glorification of the *Madonna della Vallicella*, the fragment of a fourteenth-century detached fresco credited with numerous miracles, incorporated into the central section with a shutter mechanism, and uncovered on significant liturgical occasions (the four periods of precept and the Feast of Vallicella in September). The glaring novelty of the decoration, regarded as an early work of baroque art, was the division of a single scene into three parts. The central section, which shows the Vallicella icon, copied by Rubens to conceal the original fresco during Ordinary Time, is flanked by two paintings featuring six saints in adoration of the Marian image: Gregory, Maurus, and Papias on the left, Domitilla, Nereus, and Achilleus on the right. The saints were chosen by Cardinal Cesare Baronio, an illustrious member of the Congregation of the Oratory, a direct pupil of Philip Neri, and the author of the *Annales ecclesiastici*, in which he reconstructed the biography of the depicted saints.

The evolution of the complex iconographic composition was the result of a series of rethinkings and challenging negotiations with the fathers of the Congregation of the Oratory, followers of Neri and keepers of the basilica. It all began with a contract signed on September 25, 1606, for the execution of just one altarpiece on canvas. The commission was offered to Rubens by the Genoese-born Monsignor Giacomo Serra, a cardinal from 1611, who financed the project with 300 scudi. The prelate's family were members of the Ligurian aristocracy, with whom the Flemish painter had dealings through the duke of Mantua, Rubens's patron during the eight years of his sojourn in Italy. At the beginning of 1608, the first canvas version of the altarpiece was withdrawn, by common accord, without being placed on the altar. In a letter addressed to Annibale Chieppio, the duke of Mantua's secretary of state, on February 2, Rubens stated that the work—now in the Musée des Beaux-Arts in Grenoble—was not being shown owing to the very poor lighting in the church. Consequently, he said, he had suggested producing a copy on a different kind of support, one better able to absorb what light there was.

To avoid having two versions of the same subject on display in the same city, the painter suggested that his patron Vincenzo I Gonzaga might buy it for 800 scudi, but he was not interested. The real reason that prompted the Oratorian fathers to reject the painting may have been the lack of importance given to the miraculous Marian image. It is clear from a Congregation directive dated January 30, 1608, that they did not like the canvas for iconographic reasons, and though the commission was confirmed, they obliged Rubens to modify at least the upper part of the composition. Rubens came up with a solution as innovative as it was grandiose. He decided not only to divide the scene into three parts—costing 200 scudi for each of the side sections, in addition to the price already agreed for the central panel—but also to work directly on site on a slate support. Before painting directly on the stone already positioned above the

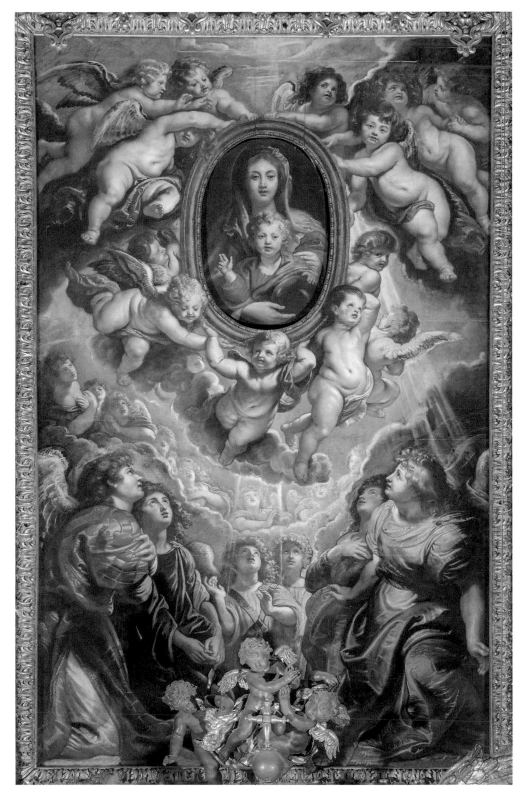

altar, Rubens had to be sure the new version would be approved by the clients. For this reason, the Oratorians requested a preparatory model, now held in the Barockmuseum in Salzburg.

Though the compactness and low porosity of the sedimentary rock typically accentuate the luminosity and realism of complexions, the Vallicella altarpieces were treated by Rubens in a way that erased the natural peculiarities of the stone support. Instead of the traditional dark and thin primers, used, for example, by Sebastiano del Piombo as the color ground onto which he then applied shiny resin-based varnishes, Rubens covered the slabs with a thick yellow-orange preparation and an even, pale gray primer. His aim was to minimize the absorption of oil into the slate and likewise the visibility of the natural coloring of slate. He also made minimal use of varnishes. The choice of the stone support was not, therefore, dictated by particular considerations regarding color or light. Slate undoubtedly provided greater protection from the dampness of the church. It also made it possible to construct the special shutter mechanism used to lower Rubens's copy of the Marian image and reveal the medieval icon (which would have been impossible with canvas). It is plausible, therefore, that Rubens used slate for intellectual reasons. Painting on stone has very ancient origins; it is discussed by Pliny the Elder in his *Naturalis historiae* and by Vitruvius in *De architectura*, and the allusion to the Classical world would not have escaped an intellectual and scholar of antiquities like Rubens.

The notion that the artist's desire was to make painting eternal by using a stone support is lent further credence by the decision to produce the image of the Virgin on a sheet of copper, an equally durable material. Moreover, Rubens was a great expert on stones and their symbolic meanings, an interest that had also been stimulated by seeing the duke of Mantua's collections of minerals and precious stones. Evidence of this passion can be seen in the details of the pictorial decoration, which feature various gems and precious stones: the design of the diadem worn by Saint Domitilla is similar to the incrustations of semiprecious stones set onto the slab of marble in the adjacent chapel of Saint Philip Neri, the building of which started in 1600. Precious minerals were seen as a symbol of the greatness of God manifested in nature and, consequently, suited to glorifying the funerary chapel of a saint, his earthly dwelling. Furthermore, the red, blue, and golden ochre tones of the saint's clothing, painted with an iridescent saturation of color that transforms the perception of the fabric into stone, recall the marbles chosen for the nearby Cesi Chapel (1589–1603). In the Roman world, red porphyry was associated with imperial dignity and for this reason was later interpreted in a Christian key as an emblem of the kingdom of God; lapis lazuli blue is a symbol of eternal life, because the silver-veined color is reminiscent of the heavenly vault; and gold, the supreme precious metal, refers to the union between earthly glory determined by rectitude and the reward of eternal life.

Cecilia Paolini

Convent

- Antonio Tempesta, *Resurrection of Christ*, oil on alabaster, ca. 1600

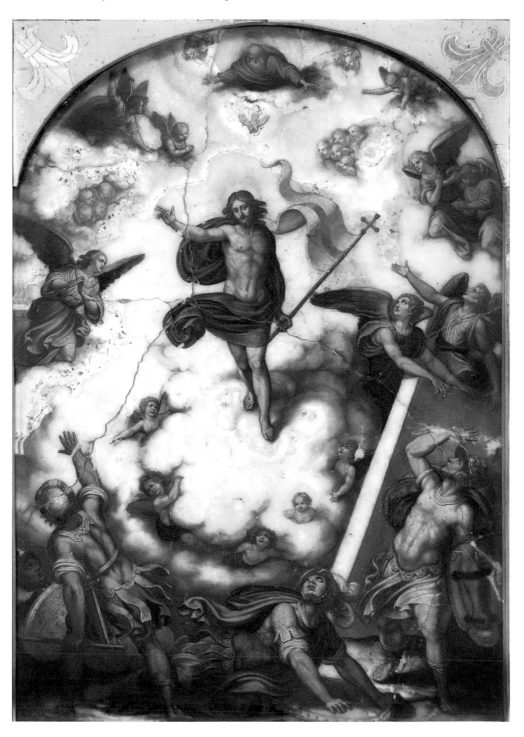

In the rooms of Saint Philip Neri in the convent of Santa Maria della Vallicella is a *Resurrection of Christ* painted on alabaster (50 × 35 cm) and attributed to Antonio Tempesta. Christ blessing is in the center, surrounded by adoring angels and the heads of cherubs; at the top of the composition, God the Father opens his arms to the Son with the dove of the Holy Spirit between them, forming the iconography of the Trinity. At the bottom, in the foreground, Roman soldiers are frightened and blinded by the divine presence.

The painter and etcher Tempesta worked for the Oratorian fathers on many occasions, collaborating in particular on the realization of etchings, based on drawings by Giovanni Guerra, to illustrate the treatise *De sanctorum martyrum cruciatibus* by the Oratorian Antonio Gallonio. Tempesta often used a stone support for oil paintings, for instance, the Galleria Borghese's *Adoration of the Magi* and the *Taking of Jerusalem*. His skill in working with colored and veined slabs was fundamental for the tradition of painting on stone. The characteristic feature of the Florentine artist's approach was the economical way in which he worked his material, exploiting the natural chromatic qualities of the support: the clouds supporting the figure of Christ are, in fact, the veining of the stone, and even the organization of the fully lit parts, contrasting with the dimness into which the soldiers seem to be swallowed up, is largely adapted to the changeability of the alabaster. The virtuoso skill in minimizing the use of paint is in keeping with the taste of collectors at the end of the sixteenth century, who appreciated the vagaries of nature as an intellectual stimulus and as a sign of divine greatness; comparison with the human skill of the painting was a further way of exalting the beauty of the stone. The choice of alabaster to depict the resurrected Christ is not coincidental: it references the stone of the tomb in which Jesus was placed and which was found empty by the devout women, thereby symbolically exalting the meaning of the resurrection.

Cecilia Paolini

Ruiz Chapel

- Girolamo Muziano, *Deposition of Christ*, oil on slate, 1566–1568
- Girolamo Muziano, *Christ Healing the Blind Man*; *Christ Healing the Paralytic*; *Saint John the Evangelist*; *Saint Matthew the Evangelist*, oil on slate, 1566–1568

Apsidal vault:
- Girolamo Muziano, *Christ Raising Lazarus*; *Christ Healing the Possessed Man of Capernaum*; *Christ Healing the Centurion's Servant*; *Three Prophets*, oil on copper, 1566–1568

Entrance archway:
- Girolamo Muziano, *Saint Francis Praying with the Crucifix*; *God the Father Blessing*; *Saint Jerome Adoring the Crucifix*, oil on copper, 1566–1568

Pilasters:
- Federico Zuccari, *Saints Luke and Mark*; *Ecce homo*; *Christ Bearing the Cross*, oil on slate, 1571

The name of the church of Santa Caterina dei Funari originates with the rope and hemp makers who plied their trade in the Sant'Angelo district. An earlier building is mentioned in 1192 in a bull of Celestine III; in 1536, Pope Paul III granted it to Ignatius of Loyola, who, in 1560, recommended that Cardinal Federico Cesi finance the total rebuilding of the church and dedicate it to the fourth-century martyr Saint Catherine of Alexandria. Cesi took him up on the suggestion and that same year commissioned the architect Guidetto Guidetti to do the work, which he completed in 1564. Adjacent to the building were the conservatory rooms for destitute maidens; in a papal bull, Pius IV specified that this facility was intended for "spinsters, mostly daughters of courtesans or women of ill repute and people in extreme poverty, who either because of a lack of care from their relatives or the hardships of poverty, or the bad domestic example of their impure mothers, could easily lose their honor." According to sources, on November 25 each year, on the Feast of Saint Catherine, girls were led in procession through the streets of the district to be chosen by their future husbands.

The interior of the church has Corinthian pilasters, a rectangular presbytery, and six richly decorated chapels; there is a profusion of white and gold stucco, polychrome marble, and brightly colored paintings, contrasting with the single-aisle vaulted nave, which is bare and somewhat austere, a style that fulfills the requirements promoted by the Council of Trent regarding the simplicity of spaces for the devout.

The Ruiz Chapel, the second on the right, dedicated to the crucifix, was commissioned by the Abbot of Summaga (Venice) Filippo Ruiz, of Valencian origin—not to be confused with Ferrante Ruiz, one of the founders of the Hospital of Santa Maria della Pietà or dei Pazzerelli— whose tombstone is in the floor at the entrance and is also recognizable by the coat of arms carved on the balustrade of the chapel, a rampant lion holding a fleur-de-lis.

The altarpiece, painted by Girolamo Muziano, depicts the *Deposition of Christ*, whose body transversally cuts across the composition with the candid whiteness of his shroud and flesh, while the pious women grieving in brightly colored dresses surround him. On the sides are

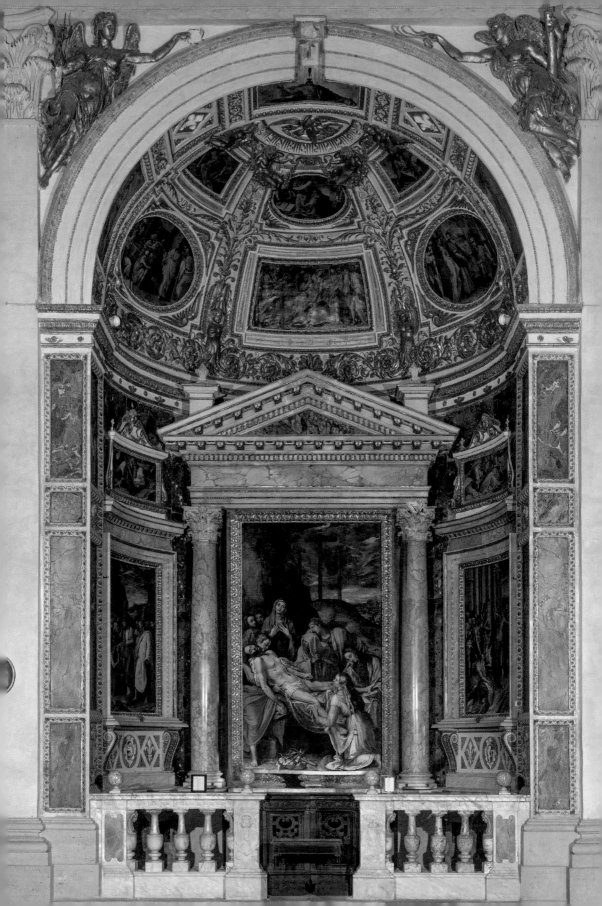

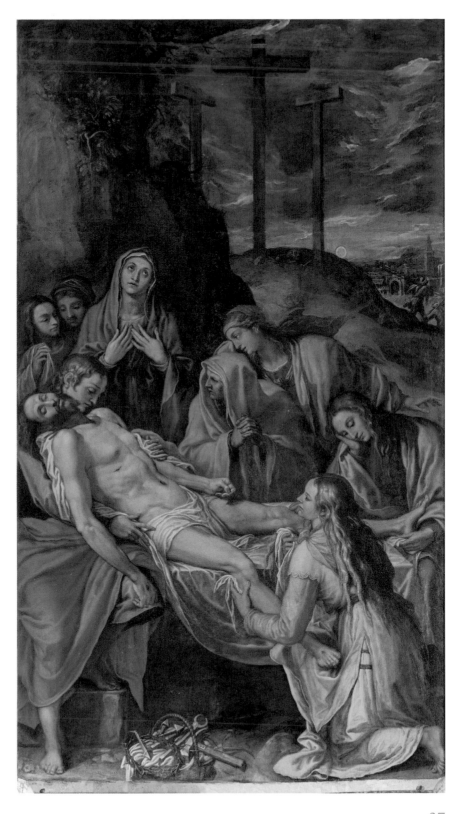

Christ Healing the Blind Man and *Christ Healing the Paralytic*; in the upper panels are *Saint John the Evangelist* and *Saint Matthew the Evangelist*. In the vault or canopy are various scenes from the life of Jesus, all works by Muziano. On the pilasters surrounding the chapel are *Saints Luke and Mark* at the top and, at the bottom, the *Ecce homo* and *Christ Bearing the Cross*, painted by Federico Zuccari, as indicated by the artist's signature, "FEDERICVS ZVCCARIS FACIEBAT" at the top left and "ANNO DOMINI MDLXXI."

Muziano painted on both copper plate and slate, demonstrating remarkable skills in the use of these different supports through an excellent rendering of color. The use of copper in particular appears to be an unusual choice for the decoration of a vault; this is possibly the sole example in sixteenth-century Roman aristocratic chapels and also in the work of the artist, probably inspired by Flemish models.

From an iconographic point of view, the painter followed the client's dictates to the letter, but he closely scrutinized the decorative scheme of the destroyed Massimi Chapel painted by Perino del Vaga in the church of Trinità dei Monti (1538–1539), which had some episodes in common with the Ruiz Chapel.

Colored marbles cover the entire structure, from the altar shrine to the pillars at the entrance, extending over the entire wall surface up to the font and on the floor covered in *opus sectile* with rhombuses in white, African and antique yellow, and portasanta marbles. This decoration bears witness to a detailed and sophisticated variety of stones intended to create a unique chapel, in accordance with the wishes of Abbot Ruiz, who specified in his will that he personally designed the ornaments.

Francesca Parrilla

De Torres Chapel

- Marcello Venusti, *Saint John the Baptist*, oil on slate, ca. 1571–1573
- Marcello Venusti, *Beheading of John the Baptist*; *Portrait of Ludovico I de Torres*; *Portrait of Ludovico II de Torres*, oil on slate, ca. 1571–1573

Apsidal vault:
- Marcello Venusti, *Birth of Saint John the Baptist* (oval); *The Visitation*; *Sermon of Saint John the Baptist*; *Two Standing Saints* (oval); *Announcement to Zachariah*, oil on slate, ca. 1571–1573

The decoration of the Chapel of San Giovanni or De Torres, the third on the left as one enters the church, was promoted by the archbishop of Monreale, Ludovico de Torres, president of the Apostolic Chamber and a great diplomat of the Christian League against the Turks (portrayed in the left tondo of the middle band). In the terra-cotta floor of the church facing the chapel's entrance are five white marble tomb slabs with the bas-relief coats of arms of the family whose name the chapel bears.

The chapel, dedicated to Saint John the Baptist to honor the memory of the patron's father, Giovanni de Torres, stands out in the church's nave for its unparalleled and exuberant use of stucco and gilding and the use of slate as a support for all the paintings in its interior.

Originally from Spain, the De Torres family had moved to Rome at the behest of Ludovico's brother, Ferdinando de Torres, described by the chronicles of the time as "extremely wealthy." In a ledger of revenues and expenditures at the State Archives in Rome, compiled in 1640 by a nun of the monastery of Saint Catherine, we read: "The sixth [chapel], that is Saint John the Baptist in oil, is the work of Signor Marcello Vetusto [Venusti]; said chapel was made by Signor Abbot De Torres." The register confirms the contents of early-seventeenth-century sources that already attributed the decoration of the entire chapel to Venusti in the 1670s.

The altarpiece depicts a melancholy *Saint John the Baptist*, wrapped in a red cloak, against a gloomy background. In his pose, there is no lack of references to classicism and Michelangelo's nudes in the Sistine Chapel. The two main episodes of the saint's life are depicted in the side panels: the *Baptism of Christ*, with God pointing out the event from on high, similar to the scene of the *Conversion of Saul* in the Pauline Chapel in the Vatican, and the *Beheading of John the Baptist* at the hands of a torturer who, with a grimace of mocking cruelty, hands the saint's head to Salomé. In the vault of the apse, which features lavish stucco decoration, are other paintings with varying geometric shapes, partially retouched at an unspecified date. The section with the *Visitation* is quite similar to the canvas installed by Venusti a few years later in the left side panel of the Capranica Chapel in Santa Maria Sopra Minerva. Some preparatory drawings for the panels depicting the *Birth of Saint John* and the *Announcement to Zachariah* are known, preserved, respectively, in the Stockholm Nationalmuseum and the Pushkin Museum in Moscow.

The entire iconography follows the rules dictated by the Counter-Reformation church, re-proposed in those years by the various martyrologies, particularly the *Annales ecclesiastici* of Cardinal Cesare Baronio, who specifically dedicated part of the work to Ludovico de Torres.

Unlike in the Ruiz Chapel, the polychrome marbles only decorate the central part occupied by the altar; the frame enclosing the altarpiece is made of portasanta, white, and antique green marbles and is flanked by two white marble caryatids and two columns in antique green marble supporting the entablature, in a chromatic contrast that almost dissolves the architecture, creating a veritable masterpiece for the eyes.

Francesca Parrilla

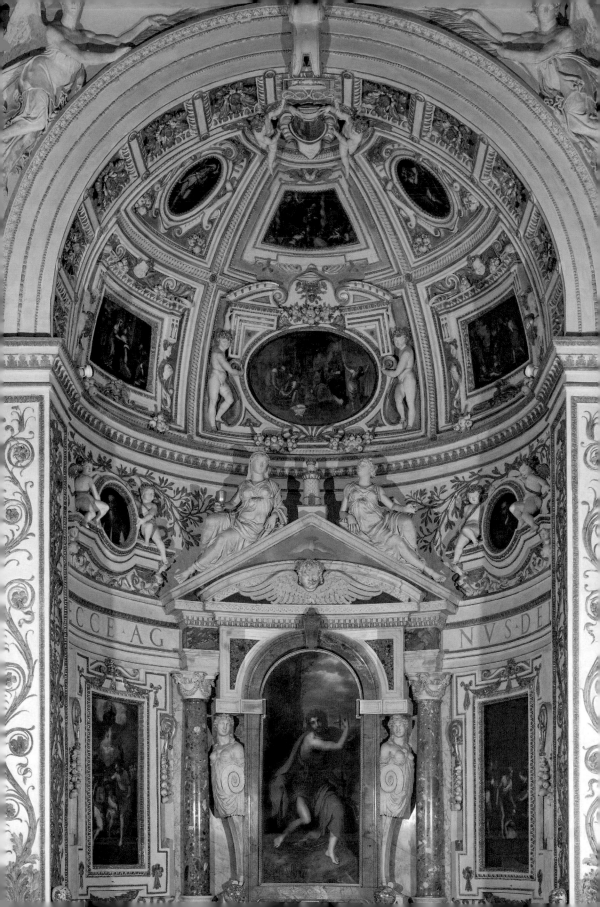

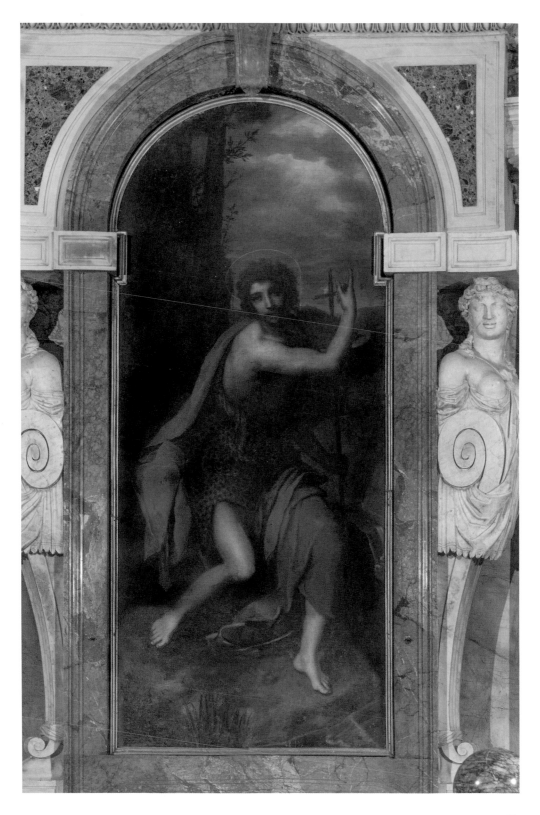

Chapel of the Conservatori

- Marcello Venusti, *The Virgin Mary in Glory between Saints Peter and Paul*, oil on slate, before 1578

The Palazzo dei Conservatori is situated in the Piazza del Campidoglio and, together with the Palazzo Nuovo and the Tabularium, houses the Capitoline Museums.

The building was occupied by the elected municipal magistrates (the Conservatori). Drawn from the ranks of the city nobility, they had the task of administering Rome together with the senator.

The original late-medieval façade of the palace was redesigned by Michelangelo, who went on to plan the square in front as well. However, he died before completing the work, which was later finished by the architect Guidetto Guidetti and by Giacomo della Porta, who followed Michelangelo's designs very closely.

The sixteenth-century transformations also altered the internal appearance of the building: besides the new windows, the laying of a Genoese brick floor, and the addition of numerous fresco decorations, it was decided in 1575 to turn the final section of the counterfaçade above the new portico into a chapel. This small room (6.6 × 4 m), dedicated to the Virgin Mary and to Saints Peter and Paul, was decorated in 1575–1578 by Jacopo Rocchetti and Michele Alberti with gilded stuccos and four panels in the vault depicting episodes from the life of the city's two patron saints. An opening had been inserted into the side wall on the left, covered by a grate, making it possible to follow Mass from the adjoining Sala dei Capitani. Around the same time, "M.ro Marcello [Venusti]" was paid around 80 scudi for "the paintings in the niche of the altar in the chapel." The document for this still divides critics: according to some, it refers to a fresco decoration in the niche, subsequently destroyed in later renovation work; according to others, it relates to the painting on slate currently above the altar. There is a record of it being in the chapel from the beginning of the nineteenth century, with an attribution to Sebastiano del Piombo, probably because the use of stone support is generally associated with the Venetian painter, but there is no saying that this was its original position. Later it was linked to the Umbrian artist Avanzino Nucci. There is no doubt that the work, depicting the *Virgin Mary in Glory between Saints Peter and Paul*, with Rome in the background, is by Venusti. It can be compared to other altarpieces produced by the painter in the 1570s, when, after the loss of direct ties with Michelangelo, who died in 1564, the formal traits of his youth reemerged and Raphaelesque compositions predominated. This trend began with the *Saint Bernard* of 1564, now in the Pinacoteca Vaticana, in which the Michelangelesque influence already appears diluted, and it became established in the early 1570s with his *Saint John the Baptist* on slate in the De Torres Chapel (itin. 8), which, with its Classical lyricism, marks an independent stylistic turning point. Also belonging to the same phase is the Porcari altarpiece in the church of Santa Maria sopra Minerva, which shares with the work in the Palazzo dei Conservatori both the Raphaelesque compositional structure and the physiognomy of the faces of Saints Peter and Paul.

It is also interesting to note that Tommaso de' Cavalieri, one of the most interesting figures in Michelangelo's close circle and a key player in helping Venusti's Roman career get off the ground, held the post of deputy on the Campidoglio building site between 1555 and 1575. He was responsible for the artistic choices relating to the building, and so it is possible that it was Cavalieri who put forward the artist's name for the execution of the work, with the aim of

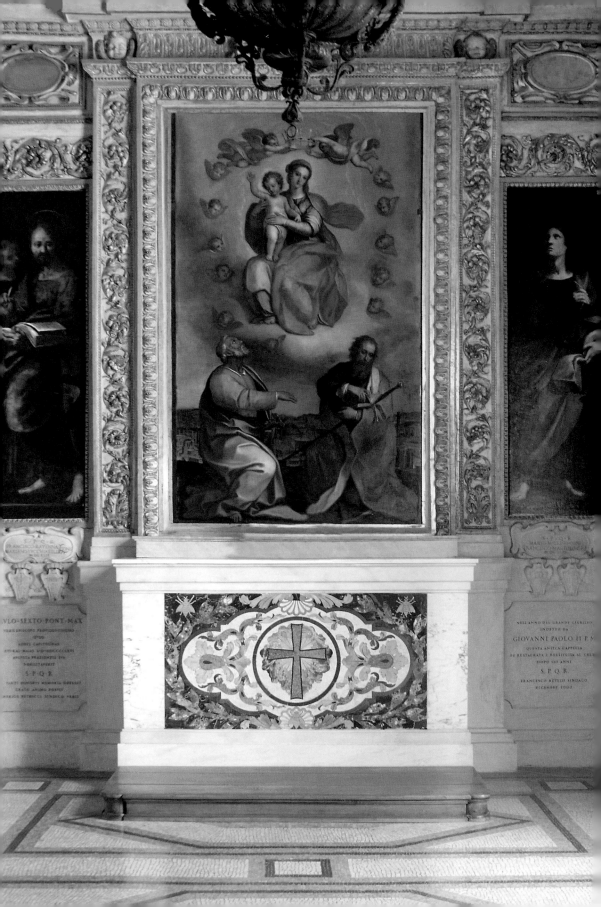

ensuring that the overall decoration of the small chapel was in keeping with Michelangelo's legacy. A document dated December 23, 1578, indicates that the carver Flaminio Bolonger sculpted "the ornamentation around the figure of the Madonna," and so by that date the work (fresco or altarpiece) must already have been executed.

Observing the painting, the city seems to be viewed from above, probably from the Capitoline Hill, as evidenced by the position of the monuments visible in it: on the right is an obelisk, which is probably the one situated next to Santa Maria in Aracoeli until 1582, while in the middle is the Pantheon, set in the dense urban fabric. The link with the Palazzo dei Conservatori is therefore explicitly declared. The support in stone also attests to the lasting and solid power that the magistrates proudly affirmed with respect to the Roman Curia.

Many alterations were made to the chapel after 1870. In particular, the decoration on the end wall was removed to pave the way for a new entrance. In the following century, efforts were made during the restoration of the Capitoline complex to restore the old structure of the altar, modified by nineteenth-century interventions, which now has a rich frontal adorned with colored marbles and the bees of the Barberini coat of arms, probably executed during the pontificate of Urban VIII (1623–1644). It may have been in the seventeenth century that Venusti's presumed frescoes were destroyed and replaced with the altarpiece originally in another room of the palace; the paintings of evangelists and Roman saints by Giovan Francesco Romanelli were presumably put on the walls at the same time. On the long wall opposite the window, covering the gilded grating, is the detached fresco of the *Madonna and Child* by Andrea di Assisi, formerly in the palace's fifteenth-century loggia.

Francesca Parrilla

Hall of Triumphs

Paolo Piazza (Fra Cosimo da Castelfranco), *Dead Christ Supported by an Angel* • *with Saint Francis in Prayer*, oil on slate, 1614

Entering the Sala dei Trionfi (Hall of Triumphs), where until a few years ago the *Spinario* (or *Boy with Thorn*), a fine first-century BCE bronze, was on display, one can admire the *Dead Christ Supported by an Angel with Saint Francis in Prayer* by Paolo Piazza (Fra Cosimo da Castelfranco), a large work on slate signed and dated 1614.

As Pompilio Totti recalled in his 1638 guide, this was the "room, where the Illustrious Conservatori eat, adorned with red damasks trimmed with gold, with chairs in red velvet with gold trimmings, and a table with the same velvet. Frieze around top of said room, painted by an excellent master; she-wolf with two suckling boys in bronze; . . . painting of a Dead Christ, with a Saint Francis, by the hand of Father Cosimo Capuchin." Christ's naked body, illuminated by the flame of the candle in the background, is portrayed half lying on the cross that is resting on the ground, his shoulders supported by an angel, whose wings barely emerge from the dark shadows; on the right is the kneeling Saint Francis, who keeps vigil with his hands joined in prayer.

The painting, which has iconographic precedents going back to Titian and typically Bassanesque effects of light, is built into the inside wall of the room, bordered by a marble frame with a plaque at the bottom listing the names of the Conservatori in office from October 1614 and of the prior of the *rioni* chief ("FRANCISCO DE RVSTICIS/IVLIO DE MAGISTRIS COSS/MARCELLO MVTO DE PAPAZVRRIS/PETRO LENO CAP. REG. PRIORE/SVMPTIBVS SVIS/MDCXIIII").

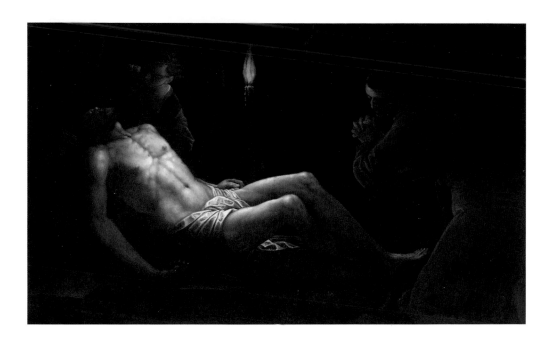

The artist was summoned to Rome by Pope Paul V to decorate the Borghese palace in Campo Marzio, which occupied him from January 1614 to the summer of 1615 and subsequently from August 1616 to July 1618, where he painted large friezes in oil on stucco. During these years, he became familiar with new artistic trends, demonstrating, with his work for the Conservatori, an ability to experiment with different pictorial techniques, though this was just an interlude in his activity. The large format of the *Dead Christ* differentiates him from painters of other smaller compositions on slate that began to circulate in Rome in those years with the Veronese painters Pasquale Ottino and Alessandro Turchi, who had dealings with the Borghese family. However, while the Veronese artists moved in a Caravaggesque direction in their use of plastic and light effects, Piazza concentrated on a pathetic rendering of the subject through the afflicted expressions of the characters.

It has recently been clarified that the presence of Piazza's work on slate in the palace is due to the *conservatore* Francesco Rustici (1543–1617), named in the plaque, the last member of a Capitoline noble family who was a member of various confraternities. He was particularly devoted to his patronymic saint and to the Capuchin order. Indeed, he gave to the latter the Caravaggesque canvas with *Saint Francis in Meditation*, which is still in the church of the Immacolata Concezione today.

Francesca Parrilla

Pinacoteca

- Francesco Albani, *Madonna and Child with Two Angels*, oil on slate, ca.1630

In 1765–1766, in the "small room of the old chapel" in the Palazzo Senatorio in Campidoglio, there was a "painting on slate on the wall, representing the Holy Madonna with the Holy Child, flanked by angels," recently identified as the *Madonna and Child with Two Angels* (on display in the exhibition *Timeless Wonder*, but usually housed in the room of Saint Petronilla). The old location of the work, which confirms a devotional use for the painting, suggests that it was commissioned by the Capitoline magistrates or by a senator in seventeenth-century Rome. Around the middle of the twentieth century, the work was removed from the council offices and put on display in the museum, with an attribution to Francesco Albani, a name initially proposed by Roberto Longhi and then unanimously accepted by other critics. The painter was in Rome from 1601, where he collaborated with Annibale Carracci on the decoration of the church of San Giacomo degli Spagnoli. It was probably while he was in Rome that Albani first began experimenting with painting on stone, displaying a fondness for small-format works with just a few figures. This can be seen, for example, in the *Madonna and Child*, also in the Pinacoteca Capitolina (from the Sacchetti collection, room VI), painted on slate, a work the artist replicated several times on different materials. The number of figures in the *Madonna and Child with Two Angels*, likewise on slate, is also kept to a minimum, but in this case, the support is of considerable size and weight, comparable to those of the altarpieces on stone painted in Rome during the sixteenth century. This refined representation is one of the most effective examples of the use of slate in painting, in which the lively colors of the brushstrokes stand out against the dark unpainted part, achieving the force of an altarpiece on a stone support in a smaller horizontal format. The decision to leave most of the support unpainted, besides empha-

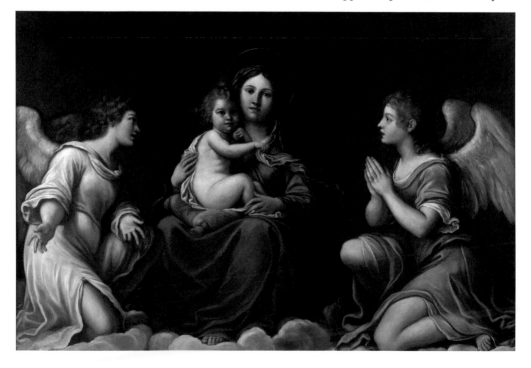

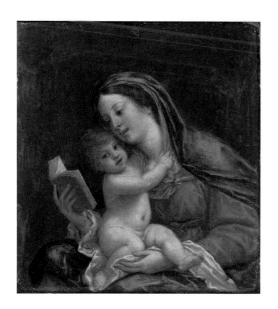

sizing the material, may have been determined by the artist's intention to evoke the gospel episode in which Christ designates Peter as the rock on which the church is founded. The kneeling angel on the left with his arms open, directing the eye toward the Child, amplifies the viewer's experience. In the background support, it is also possible to discern an allusion to the Stone of Unction and to the tombstone associated with the death and sacrifice of Christ, who is in the center of the painting and is at the center of the Christian faith. It is no accident that the Child is holding an apple in his left hand, symbolically assuming the burden of original sin for the salvation of humankind. The result is a work of great intensity, imbued with powerful religious feeling.

Pier Ludovico Puddu

Transept

- Marcello Venusti, attributed, *Funeral Portrait of Alessandro Crivelli*, oil on slate, 1571

From the entrance to the church, through three large and bright naves articulated by twenty-two antique columns with Doric and Ionic capitals, the visitor reaches the transept, where on the left one can see the funerary monument of Cardinal Alessandro Crivelli (1511–1574), realized in 1571, during his lifetime. Descended from the Crivelli family, counts of Dorno and Lomello, Alessandro was made cardinal by Pope Pius IV on March 12, 1565, for his contribution to the effective conclusion of the Council of Trent.

The simple architecture of the monument is typical of Roman tombs of the cinquecento, where the shiny polish of the black stone, used for the structural parts, contrasts with the lackluster finish of the reliefs in white marble. On the upper section of the temple-like structure, on the pediment, is a *Trinity* attributed to Jacopo del Duca (1520–1604), formally and stylistically indebted to his old master, Michelangelo. The dramatic tension created by alternation of solids and voids that intensifies the reflection of light on the surfaces is set against the solemnity of the cardinal's portrait underneath, in oil on slate, attributed to Marcello Venusti. The oval is placed within a marble frame, with scrolls in the central part, and surrounded by an elegant inscription with the information of the date of his death in 1574. The cardinal is portrayed in the moment of his nomination, with his left hand to his breast, while he holds the tasseled hat, barely visible, that he has just received from the pope.

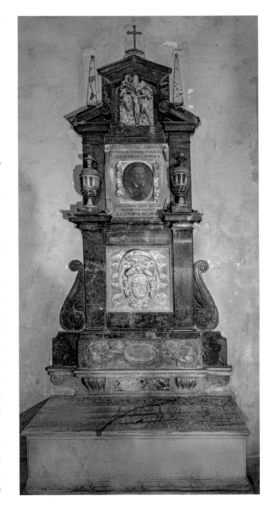

Venusti had already painted on slate, for example, in the Mutini Chapel in Sant'Agostino (itin. 2), in the De Torres Chapel in Santa Caterina dei Funari (itin. 8), and the Lante della Rovere in Santa Maria Sopra Minerva. Moreover, the seventeenth-century inventories of the Barberini collection attribute to him various small paintings on stone. Through his skillful use of shadow in the hollowed eyes and the deeply realistic furrows in the forehead, Venusti confers psychological depth to the portrait of the cardinal.

Stylistic elements typical of Venetian painting can be detected in the refined distribution of the light on Crivelli's countenance, a characteristic that can also be observed in the

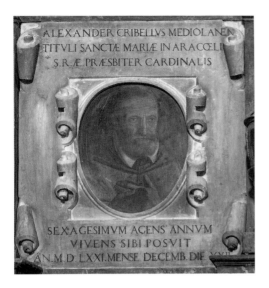

Mignanelli altarpiece in Santa Maria Sopra Minerva realized in 1569, which Venusti probably derived from Sebastiano, whom he much admired, especially in his mature phase. In all likelihood, he was also inspired by Sebastiano in the choice of slate as a pictorial support.

In the lower register of the monument, one can see the imposing coat of arms of the Crivelli, a shield with a black eagle and the other heraldic symbols of the family, surrounded by vegetable scrolls and surmounted by the cardinal's hat. Underneath, two unicorns hold torches around a sieve, in an original reference to the last name of the deceased.

Mario Casaburo

Side Entrance

- Anonymous, *Funeral Portraits of Sertorio Teofili and Ortensia Cinquini*, oil on slate, ca. 1605

In the lateral atrium, toward the capitol, are the funerary monuments of Teofili Sertorio, a concistorial lawyer, and his wife, Ortensia Cinquini. In order to install them on the wall, the arrangement of the preexisting tomb of Cardinal Pietro Manzi, Sertorio's ancestor, which is attributed to Andrea Sansovino, had to be modified,

The architecture is extremely simple: two tombstones in black marble with long inscriptions and a date suggesting that they were executed before 1607 (the year of Sertorio's death), when husband and wife were still alive. Above the tombstones are two slabs of white marble, in which the portraits are inserted, two ovals in oil on slate, presumably painted by a local workshop active in this kind of production. Unfortunately, Ortensia Cinquini's features are hardly recognizable, as her portrait is poorly preserved.

The custom of portraying a deceased on slate, or in other kinds of stone—that is, on lithic supports as durable as sculpture—must be read as a wish to perpetuate the memory of their virtue and moral strength. The abundant presence in Rome of portraits on stone in chapels and funerary monuments, usually by anonymous local workshops but occasionally by famous artists, testify to this fashion. Today these portraits offer a vast sample of physiognomies, postures, and psychological types, useful in documentary terms, as a sort of portrait gallery that one can admire by visiting various churches in the city.

Mario Casaburo

Delfini Chapel

- Giovanni De Vecchi, *Penitent Saint Jerome*, oil on slate, 1572–1573

The splendid Delfini or San Bonaventura Chapel is the third chapel from the end as one walks along the right aisle of the church. It houses the *Penitent Saint Jerome*, an altarpiece on slate (260 × 160 cm) painted by Giovanni De Vecchi (1536–1615).

The chapel was originally built by the Mattei family and dedicated to Saint Jerome. It was later taken over and completed by the Delfini, a family of nobles who moved to Rome from Venice in the fifteenth century. The chapel holds the funerary monuments of Mario Delfini and his son Gentile, who died at an early age in 1559.

In 1875, following restoration work commissioned by Bernardino da Portogruaro, the minister general of the Franciscans, the chapel was named after Saint Bonaventure; on this occasion, Alessandro Palombi was employed to redo the architectural decorative scheme. De Vecchi's frescoes on the side walls were in a poor state of preservation and were replaced by his *Penitent Saint Jerome* and a *Saint Anthony of Padua* painted by Ludovico Seitz, an artist of German origin.

It was decided to leave the altarpiece in place, as the weight of the slate slabs would have made it difficult to move elsewhere, and to cover it with a painting by Franz von Rohden. It was not until the latter was stolen a few decades ago that the altarpiece could once again be seen.

Critics more or less concur in attributing the *Saint Jerome* to De Vecchi on stylistic grounds and in dating it to 1572–1573, the date that appears on the inscription on the tomb of Mario Delfini, who commissioned it. Following the removal of thick nineteenth-century repaintings in the course of the latest restoration, it was established that the fresco decoration in the four sections of the vault cannot be ascribed to the same painter.

The saint is depicted in a standing position with his body leaning slightly forward. His outstretched left hand is resting on a book, which symbolizes theological wisdom—Jerome was proclaimed a doctor of the church by Pius V in 1567—and refers to his *Vulgate*, the first Latin translation of the Bible (end of the fourth century). The whole painting is pervaded by a dynamic tension emanating from the slightly bent right arm of the saint, who, in an extreme act of penitence, is about to beat his chest with the stone gripped firmly in his hand. At his feet is a lion—from whose paw, according to legend, the saint removed a thorn—in a pose reminiscent of Classical sculptures. Due to the darkened paint and the precarious state of conservation of the pictorial surface, no other iconographic elements typically associated with Jerome, such as the crucifix or the skull, can be identified. The emotionally charged rendering of the face, with the eyes directed upward, seems to go beyond an academic mannerist idiom, displaying a greater expressive freedom, while the stylistic terseness and restrained decoration, together with the intense sentimentalism of the hermit, are entirely in keeping with the Counter-Reformation climate of Rome in that period.

Saint Jerome's sculptural pose suggests that De Vecchi drew inspiration from one of the models used by Michelangelo for the *ignudi* of the *Last Judgment*, presumably a drawing, marking a return to the mature Renaissance but in a more spiritual vein. The suffused atmosphere of the background and the use of saturated browns and reds clearly show influences from Venetian painting, especially that of Girolamo Muziano or, better still, Sebastiano del Piombo's late period. The use of a slate support for expressive purposes also seems to derive from Sebastiano; the technique of execution, in fact, involved a very thin preparation exploiting the dark tonalities of the stone, facilitating the distribution of highlights on the surface through chiaroscuro contrasts.

The Delfini *Saint Jerome* is therefore a perfect synthesis of Michelangelesque elements and

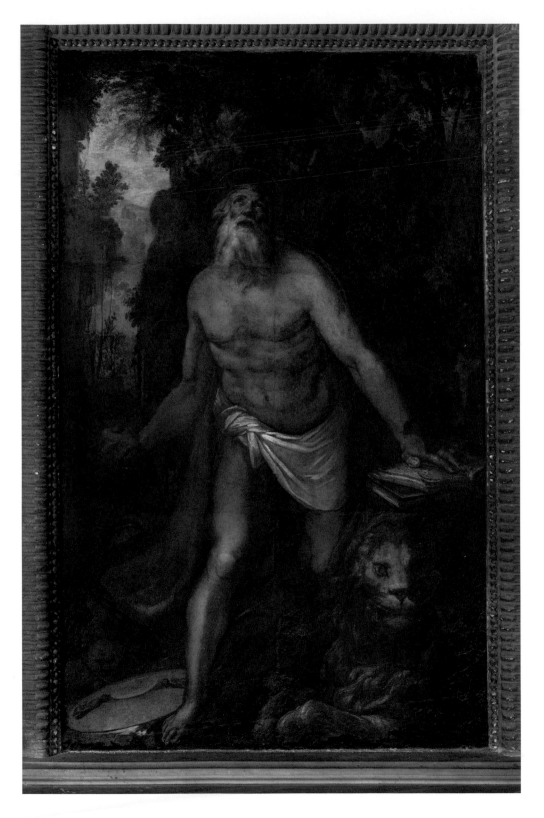

Venetian colorism, a model that was greatly admired by contemporary painters. For example, it is worth recalling the copy, perhaps attributable to Vespasiano Spada, in the Monastery of El Escorial.

The church also houses another oil painting on slate by De' Vecchi (94 × 84 cm), which can be found on the pilaster of the triumphal arch in the right transept. Produced between 1603 and 1604 for Giovan Francesco Salomonio, it depicts the *Procession of the Madonna dell'Aracoeli*. At the time of Gregory the Great, it was, in fact, customary, in times of plague, to process with the icon of the Virgin now on the altar of the church.

Mario Casaburo

Chapel of San Diego d'Alcalà

- Giovanni De Vecchi, *Saint Didacus (Diego d'Alcalà) Healing a Blind Man*, oil on slate, 1597–1610

The slate altarpiece by De Vecchi is housed off the right aisle in the seventh chapel dedicated to Saint Didacus of Alcalà. It depicts *Saint Didacus Healing a Blind Man* and was produced between 1597 and the first years of the seventeenth century. The chapel was consecrated on January 13, 1610.

The chapel, built under the patronage of the Cenci family and dedicated to Saint Lawrence in 1411, was in such a state of disrepair by the end of the sixteenth century that Father Francesco da Monreale asked the family to restore and rededicate it to Saint Didacus of Alcalà, a Spanish Franciscan canonized by Pope Sixtus V in 1588. Didacus had lived in the monastery of Aracoeli after working as a missionary in the Canary Islands.

De Vecchi, drawing on a passage from the gospel of Matthew, painted the saint in a standing position, as he is raising his right arm to hold up a lamp to cure the blind man with the light of true faith. The gesture of restoring sight is symbolic, conveying a message in keeping with the dictates of the Counter-Reformation: it served to open the eyes of the faithful and to show them the straight and narrow path they should take in order not to lose their way in the face of the spread of Protestant ideas. At the bottom of the painting, a disoriented young boy, also blind, is clinging to the man's clothing for support; further back on the right, and slightly in shadow, is a group of three figures, possibly members of the Cenci family, who are witnessing the miracle.

The work is suffused with a dramatic lyricism very similar to El Greco's paintings of the same subject. Unfortunately, the left-hand part of the altarpiece is almost entirely illegible, though it is likely that the painter intentionally left it in semidarkness to accentuate the chiaroscuro contrast with the group of worshippers on the opposite side, who are bathed in a golden light. The slate support facilitated the achievement of this expressive effect; the painter used thin brushstrokes to

skillfully apply paint in successive layers of highlights over a virtually inexistent priming, allowing the dark tonalities of the ground to emerge.

The habit of illuminating dim settings with an artificial light such as a lamp or the flame of a candle spread through northern Europe and then into the Verona area. This type of small-format devotional picture circulated widely on the market in Rome at the end of the sixteenth century, and it is likely that the Tuscan painter was already familiar with them.

In his Life of the painter Jacopo Bassano (in *Het Schilder-Boeck*, 1604), Karel van Mander interestingly states that he had seen some small paintings on stone depicting scenes from the Passion at a merchant's in Rome: "All nocturnal scenes, they were painted on black stones, in which the rays of light deriving from torches, candles, and lamps were traced onto the black ground of the stone with gold lines and then varnished." The black stone of the support was perfect, then, if left bare, to simulate a nighttime scene.

The remaining part of the chapel was decorated by Avanzino Nucci, who frescoed the vault and the lunettes with two scenes from the life of Saint Didacus (hardly any trace of the paintings on the vault now remains), and by Strada, who painted the side walls with *Saint Didacus Healing a Possessed Man* and *Bread Transformed into Roses in the Hands of the Saint*.

Mario Casaburo

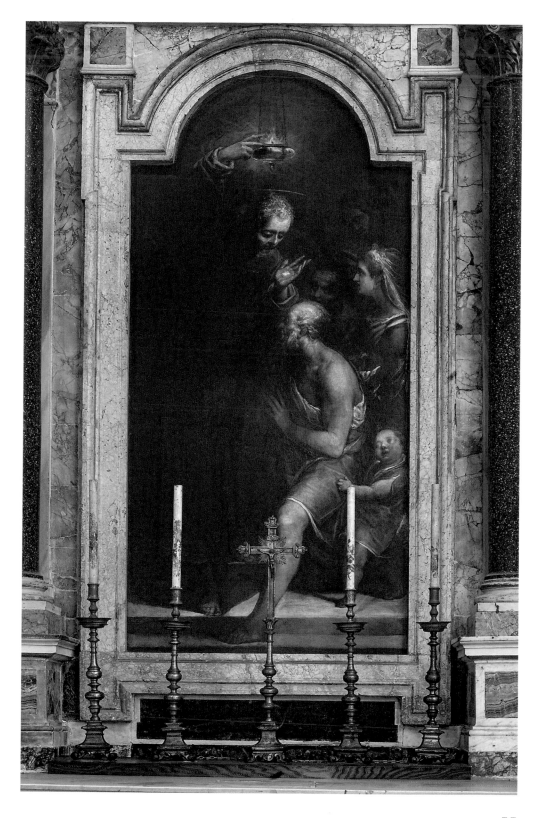

Frangipane Chapel

● Taddeo Zuccari, *Conversion of Saint Paul*, oil on slate, 1558–1566

The fourth chapel on the left of the nave in the Servite church of San Marcello al Corso on which the Zuccari brothers worked between 1558 and 1566 for the Frangipane family has a slate altarpiece. This was painted by Taddeo Zuccari (although until recently, Federico was also given a role) around 1564 and depicts the *Conversion of Saint Paul*. The immediate patron was Mario di Antonino Frangipane, who occupied various important civic offices at Rome until his death in 1569—notably as conservator of antiquities and statues. There was a pride in the family lineage, as in 1556, Onofrio Panvinio, had written *De gente Fregepania libri quatuor*, which was dedicated to Mario.

Giorgio Vasari describes how Taddeo had won this commission as a result of the success of his Mattei Chapel in the nearby church of Santa Maria della Consolazione—both the Frangipane and the Mattei were native Roman families of long standing. Vasari doesn't say, however, why Taddeo moved to a slate surface here, but he and his brother became among the most frequent users of this material. Besides their joint work at San Lorenzo in Damaso (itin. 6), Federico painted an *Adoration of the Magi* on marble for the Grimani Chapel in San Francesco della Vigna in Venice and on November 14, 1568, almost immediately after the completion of the Frangipane Chapel, he agreed to paint two altarpieces on slate for the Orvieto cathedral, *The Resurrection of the Son of the Widow of Naim* and *The Healing of the Blind Man*. These are the only large-scale altarpieces on a stone surface outside of metropolitan Rome.

Undoubtedly relevant to the choice both of a stone surface and of Zuccari for this chapel is the fact that the Frangipane were tied to the Farnese—and Panvinio was actually the Farnese librarian. Mario's recently deceased brother, Curzio, had been not only a friend of Panvinio but also *maestro di casa* to the cardinal, living in the Palazzo Farnese. It was to Curzio that the patronage of the chapel had originally been conceded by the Servite friars. Furthermore, San Marcello in the 1550s had become a church associated with the Farnese set and several others of their close associates not only lived nearby but also bought chapels in the church. Opposite, the third chapel on the right was being decorated at the same time for Matteo Grifoni, bishop of Trivento and friend to Cardinal Alessandro, by Francesco Salviati. For the Frangipane between 1558 and 1566, the Zuccari brothers completed the decoration of the whole chapel with stories of the life of Saint Paul, but only the high altar is painted on slate. The choice of subject matter would seem an obvious homage to the recently deceased pontiff, Alessandro Farnese, Paul III. As with the Grifoni, even the choice of artist would appear to be linked to this Farnese connection, although the eight years the chapel took to complete shows how much the Zuccari brothers were now in demand.

In the center, Saul is struck from his plunging horse by the thunderously downstretched hand of God the Father, encircled by a golden nimbus, while members of his entourage turn away in horror. Furthermore, this subject matter, of course, recalls deliberately the famous painting by Michelangelo in the Pauline Chapel, completed only ten years earlier, albeit on a much more restricted scale, almost a close-up of the central section. Saul being struck down from his horse by the powerful arm of God is almost a direct borrowing, as is the horse, which is shown dramatically from the rear. In another borrowing, the figure to the right turns away from the viewer and uses his left arm to cover his face, while on the left, the blinded Saul is helped by a single figure whose face is toward the viewer.

Piers Baker Bates

Bandini Chapel

- Scipione Pulzone, *Assumption of the Virgin*, oil on slate, 1585

The grandiose Bandini Chapel, which was constructed and then decorated starting in 1580, is off the left transept of the Theatine church of San Silvestro in Quirinale. It should be one of the sights of Rome but is often hard to access today. Later urban developments have resulted in the partial destruction of this church and have relegated it to obscurity and concealed its earlier importance. From 1583 until the construction of Sant'Andrea del Quirinale in 1658, this was the nearest church to the pope's new summer residence, the Quirinal Palace, thereby occupying a prestigious site in a developing area of the city.

The altarpiece in this chapel, the *Assumption of the Virgin* by Scipione Pulzone on slate, measures 5.5 × 3.07 meters and is the artist's only work in this material. It is part of a much larger program of decoration that was deliberately intended to imitate the decoration of the Chigi Chapel in Santa Maria del Popolo. The early designs of the architect, Ottavio Mascherino, demonstrate this clearly, including the central role played by the altarpiece. The patrons were Florentines—Pierantonio Bandini, the wealthiest banker in Rome, and his son, Monsignor Ottavio, a future cardinal—and the chapel was founded in memory of their son and brother Francesco, who had died the previous year. Not surprisingly, they chose to imitate the example set by another very wealthy banker, Agostino Chigi. The inclusion of a slate altarpiece undoubtedly formed part of the same rationale, as did the Bandini choice of Pulzone, probably the most in-demand artist in Rome in the 1580s, to paint it.

Right in the center at the base of this altarpiece, the artist has proudly signed himself on a painted scrap of paper: "Scipio Pulzonius Caietantis faciebat Ano Dñi 1585," recognizing his own achievement. Evidently satisfied with the composition, he later reused it, on panel, for the altarpiece of the Solano Chapel in Santa Caterina dei Funari, completed after his death in 1598 by Pomarancio.

Luckily, the restoration of 2006 has made the stone surface visible in great detail. It consists of twelve blocks of slate on six levels and was painted on by Pulzone in situ, using an oil-based primer placed directly on the slate surface in order to take the paint.

As for the actual subject matter, on the lower level, the apostles are shocked by the discovery of the empty tomb placed at an angle to the viewer, while above are the Virgin Mary and the angelic hosts. Between the two parts is a deep vista onto a landscape, at the end of which can be glimpsed a building reminiscent of the Vatican Palace.

The Bandini Chapel is particularly important because its design was created through detailed epistolary conversations that took place between Ottavio Bandini and Cardinal Gabriele Paleotti, the leading theoretician of art after the Council of Trent.

Piers Baker Bates

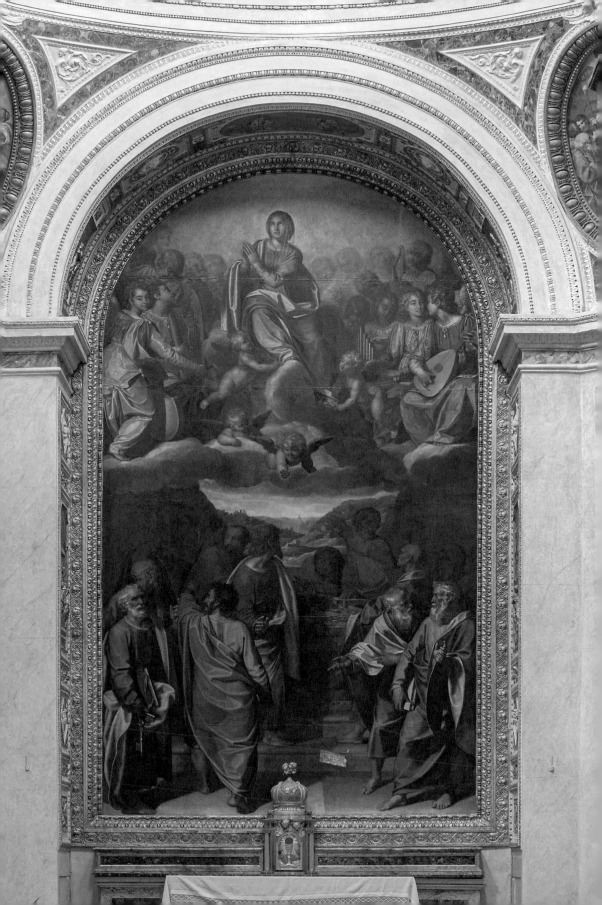

Ceuli (or Cevoli) Chapel

● Jacopo Rocchetti (Giacomo Rocca), *Crucifix with Saint Jerome*, oil on slate, 1572

The Basilica of Santa Maria degli Angeli was built over the preexisting Baths of Diocletian. In the sixteenth century, Michelangelo (1475–1564) transformed the ancient tepidarium into a Greek-cross structure with three entrances and an absidal presbytery. The main entrance leads to the vestibule, a domed rotunda with two flat-end side niches. Immediately to the right, delimited by a marble balustrade and a small gate, is the Chapel of the Crucifix, commissioned by Girolamo Ceuli (or Cevoli), a member of an influential Roman banking family, from Michele Alberti (recorded 1535–1582) and Jacopo Rocchetti (recorded ca. 1560–1605) on October 23, 1572.

The architecture of the chapel, adorned with stuccos, marbles, and frescoes, is in perfect keeping with the style of the basilica, in which Michelangelo's language engaged with Classical tradition. The orderly tripartite structure of the end wall, with a niche in the center and the slate altarpiece depicting the *Crucifix with Saint Jerome*, and the prominence of decorative marbles and stuccos with respect to frescoes are reminiscent of the Ricci Chapel in San Pietro in Montorio designed by Daniele da Volterra (ca. 1509–1566) in 1559 (itin. 19). On the side walls, respectively on the left and the right, are the funerary monuments of the sculptor Pietro Tenerani (1787–1838) and his wife, Lilla Montobbio, portrayed with sculpted busts.

The slate altarpiece was the work of Rocchetti (also known as Giacomo Rocca), who created an interesting aesthetic unity through the alternation and correspondence of the colors of the paint, marble, and sculpture. Christ, rendered in cold shades, has the function of a sculpted crucifix, positioned exactly in the center of the chapel. In the background is a landscape consisting prevalently of rocks—the line and direction can be assimilated to the veining in the marble on the walls—and a few traces of vegetation. On the left, the prostrate figure of Saint Jerome at the foot of the cross is distinguished by his customary iconographic attributes, the lion and the red cardinal's hat; in his right hand, he is holding a stone, which he is about to beat himself with in an act of penitence. On the right, and slightly apart, is the chapel's patron, Ceuli, wearing dark clothing and with his hands joined in prayer.

The arid brushwork, with graceless figures verging on coarseness, is typical of Rocchetti's style, and the painter was not spared some sardonic and unflattering comments from Giovanni Baglione: "This man was cold in his works, and nature does not lift him to noble thoughts, but summons him only to toil, and, as can be seen in his paintings, it was of little taste."

Compared with the figures at the bottom, though, the figure of Christ appears more clearly defined in its anatomical details, because the painter took as a model a drawing by Michelangelo now in the Teylers Museum in Harleem. Rocchetti inherited from Daniele a large number of drawings produced by Michelangelo, which he used on other occasions in a more or less slavish manner. On this point, Baglione wrote: Rocchetti "did little because his painting gave no pleasure, and he also cared little for hard work as he was accustomed to convenience. He nourished himself only on the beautiful sight of his drawings, which were often viewed by teachers and greatly admired by foreigners."

As for the choice of support, Rocchetti probably learned the technique of painting on stone from Daniele, who, when Rocchetti was still an apprentice in his workshop (1555–1556), did two different versions of the fight between *David and Goliath* on two sides of the same piece

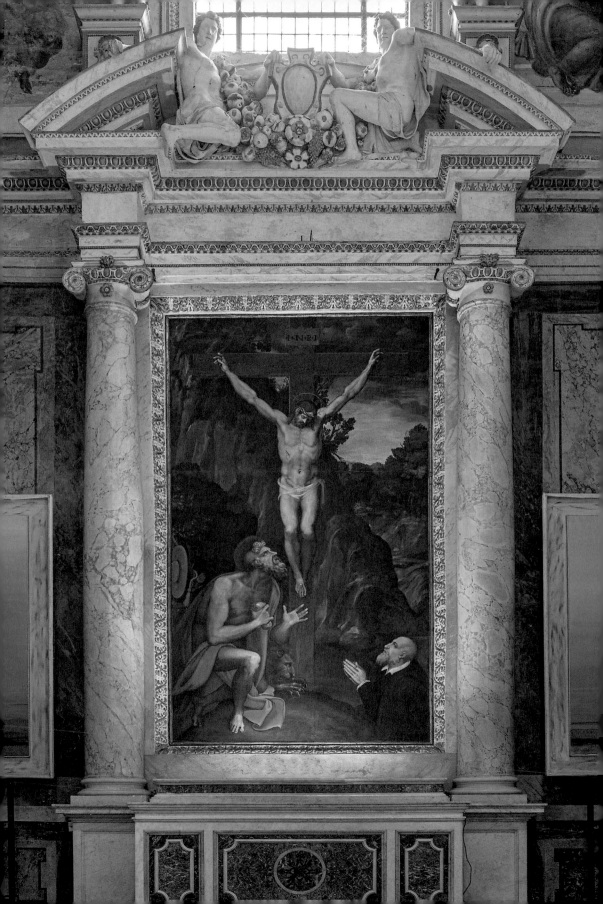

of slate (133 × 177 cm), now in the Louvre. A few years later, he reproduced the same subject in the fresco in the Palazzo Ricci-Sacchetti, executed in collaboration with Michele Alberti; he perhaps became definitively convinced of the efficacy and durability of the material when he saw the works in the Ricci Chapel, where a *Baptism of Christ* was painted on the altar on several slabs of slate. This was only planned by Daniele, in 1556, and was completed by Alberti himself in 1568 (itin. 19).

In the following years, Rocchetti's increasingly intense dealings first with Alberti and then with the Cavalier d'Arpino (1568–1640)—some of Michelangelo's drawings appear to have later passed from the hands of Jacopo to D'Arpino, establishing a continuity in the dissemination of Michelangelo's style over time—led to the painter acquiring a fairly prominent role on the Roman artistic scene in the second half of the sixteenth century.

Mario Casaburo

Presbytery

- Cristoforo Roncalli, known as Pomarancio, *Death of Ananias and Sapphira*, oil on slate, 1599–1604

For the Jubilee in 1600, Pope Clement VIII ordered that some large pictures inspired by the life of the church's first martyr saint were to be placed behind the piers supporting the dome of Saint Peter's. Painters of the caliber of Domenico Passignano, Cristoforo Roncalli (known as Pomarancio), Francesco Vanni, Ludovico Cigoli, Giovanni Baglione, and Bernardo Castello were chosen when planning the project, with slate as the preferred support for the altarpieces, as it was believed that slate would better preserve the paint in an environment that had always been affected by the damp. Unfortunately, none of the works has remained in situ, and just a few years after they were produced, they had deteriorated so much that they had to be replaced with mosaic copies.

The commission to produce the *Death of Ananias and Sapphira* initially went to Tommaso Laureti (ca. 1530–1602). By 1599, the pieces of slate had been attached to the wall, but Laureti was unable to execute the work before his death, and it was painted entirely by Pomarancio (1552–1626) by 1606. In those same years, Pomarancio was busy on another, smaller slate painting (five slabs), *Our Lady of the Assumption with Saints Matthew and Francis*, for the chapel on the *piano nobile* of the Palazzo Antici-Mattei di Giove, which may have been completed with the help of assistants.

The stone altarpiece was described by Baglione in the seventeenth century: "the cavalier Roncalli [Pomarancio] . . . painted in oil on stone the story of Ananias and his wife when Saint Peter made them fall down dead for having told lies, with many well-composed figures, and it was very satisfying." It was later mentioned by Filippo Titi in the eighteenth century. In 1721, the painting "of the lie," as it was known, was still in the basilica above the altar dedicated to Saints Peter and Andrew; in 1726, it was removed because of the damp and replaced with a mosaic copy by Pietro Adami. The original was moved to the left wall of the Tribune of Santa Maria degli Angeli, where it still is today.

The episode (Acts 5:1–10) unfolds in the foreground, in a powerful and dramatic narrative

crescendo. Sapphira is lying on the ground, while Saint Peter towers above her, gesturing with a broad movement of his right hand. The woman's outstretched arms recall the canvases in the Contarelli and Cerasi chapels—respectively, the *Martyrdom of Saint Matthew* and the *Conversion of Saint Paul*—produced in the same years by Caravaggio (1571–1610). Watching the scene is a convulsively agitated crowd of figures; in the foreground, on the right, a man with a green tunic opens his arms in a gesture of horror and impotence. Behind the crowd on the right, the architecture of a temple alludes effectively to antiquity, while the annular portico of Bramantesque inspiration provides a setting for the procession of small figures—unfortunately, not clearly distinguishable due to the work's precarious state of preservation—carrying Ananias off for burial.

The longitudinal format of the composition is emphasized by the monumental figures in the foreground and by the colonnade in the background. The artist handles light skillfully, alternating bright highlights and softer and more indefinite areas of shadow. A preliminary study for the work, in oil on canvas, produced by Pomarancio between 1599 and 1603 and now in the National Gallery of Canada in Ottawa (124.5 × 84 cm), has some formal differences compared with the definitive version.

This work is emblematic of a grandiloquent style indebted to the Tuscan tradition of the first half of the sixteenth century. The painter was an attentive observer of the naturalism of Federico Barocci (1535?–1612) but reworked it in a personal key. The result is a clean visual idiom, never explicitly mannerist and with interesting accents of light in tune with Caravaggesque innovations, which sealed Pomarancio's reputation as one of the most interesting painters on the Roman art scene at the beginning of the seventeenth century.

The altarpiece consists of around twenty-four slabs of slate fixed to the wall; the structure of the joins is visible to the naked eye today due to the deterioration of the primers used in the assembly, caused by the dampness of the pier in Saint Peter's to which the work was affixed and the trauma caused by repeated movements. The paint film is of meager thickness and pale in tone, and only the pink of Sapphira's gown and the yellow of Saint Peter's robe are well preserved. The legibility of the work is compromised by the presence of residues of varnishes applied in the nineteenth century in an effort to protect and revitalize it but which have darkened and become opaque over time. Mention should be made of the restoration carried out in 1814 by Pietro Palmaroli. He used around seventy metal nails to fix the slabs, removed the spoiled stucco, re-stuccoed the joins, and revitalized the paint surface with an invasive varnish. The work was restored again toward the middle of the nineteenth century and several times during the twentieth, becoming a paradigmatic case of the restoration of a restoration. Notwithstanding this, it is the only work in the Saint Peter's cycle that is still on public display and the only one to have survived in its entirety.

Mario Casaburo

Pauline Chapel

The Pauline Chapel (1605–1615) was built off the left aisle of the basilica by the architect Flaminio Ponzio as a pendent to the Sistine Chapel (1585–1590), which Sixtus V Peretti (1585–1590) had commissioned Domenico Fontana to build as a mausoleum for himself and Pius V Ghislieri (1566–1572). Paul V Borghese (1605–1621) followed suit by erecting the Pauline Chapel as a mausoleum for himself and his predecessor Clement VIII Aldobrandini (1592–1605). Both chapels followed the precedent set by Gregory XIII at Saint Peter's in the Gregorian Chapel (1575–1580). As in the earlier chapels, colored marbles were lavished on every available patch of wall. However, the colored marbles of the Pauline Chapel do not copy the segregated paneling of the Gregorian Chapel (itin. 18) or the heraldic patterning of the Sistine Chapel, but rather the marbles are deployed in great surfaces of pure color that divide the walls from the pilasters and so on. While the earlier chapels had relied on stones spoliated from the ancient ruins, many newly quarried stones were used to clad the Pauline Chapel, some of them quite rare and some seen in Rome for the first time.

The fulcrum of the whole chapel is the high altar and the medieval icon of the Madonna and Child it contains, known as the *Salus Populi Romani*. Tradition maintained that this icon was painted from life by no less than Saint Luke, for which reason the painted panel was not regarded as a mere artwork but held the status of a relic and, because it also effected miracles, a medium for the intercession of the Virgin. To foreground and frame the supernatural character of this icon, it was encased within a heavy gilded-bronze frame borne by gilded-bronze angels,

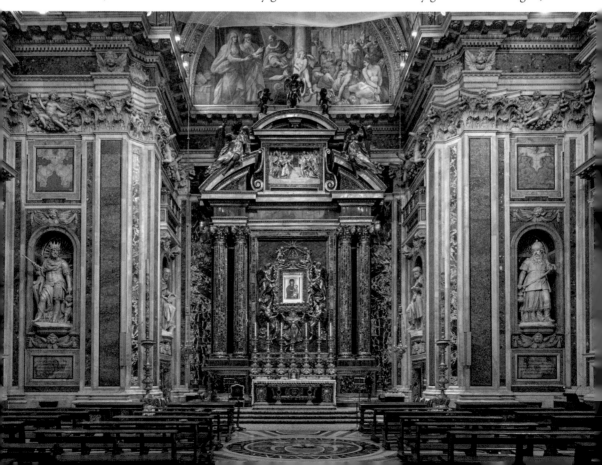

apparently hovering against a background of lapis lazuli slabs, which the contract stipulated should be "compartiti in modo che parria aria finta."(set up to resemble air). It was as though the icon had just emerged from heaven. Indeed, contemporaries likened the whole ensemble to a huge window onto a star-spangled sky. Three different gradations of lapis and an incredibly intricate degree of *commesso* work were employed to achieve the variety of cloud patterns within the azure sky. The use of a huge panel of lapis lazuli was also no doubt inspired by the use of this stone as a support both for paintings in which skies would assume prominence and, essentially for the same allusion, in representations of the Madonna, Queen of Heaven.

Moreover, the opulent altar (1611–1613) magnified trends in existing micro-architecture, particularly on richly decorated and inlaid *credenze*, *scrigni*, portable altars, and aedicules that framed paintings on stone. Thus, instead of monolithic columns of marble, we see gilded-bronze shafts inlaid with veneers of *diaspro di Sicilia*, and all the cornices, architraves, capitals, and bases are of gilded bronze. Altogether, the altar looks like a huge piece of goldsmith's work inlaid with *pietre dure*. Indeed, although the altar was designed in outline by the architect Girolamo Rainaldi, as it became more ornamental in detail and more pictorial in concept, a committee of other artists all had their say in the design, including the gentleman architect Giovanni Battista Crescenzi, the painter Antonio Tempesta, the goldsmith Pompeo Targone, and apparently Pope Paul V himself. Tempesta was a well-known painter on marbles. Targone had built the bejeweled tabernacle in the Altar of the Sacrament in San Giovanni in Laterano, itself supported by (ancient) gilded-bronze columns and featuring (modern) gilded-bronze relief. Targone also had a track record for creating gilded-bronze appliqués on panels of black marble or amethyst, thereby unifying the sculpture of bas-relief with the natural painting of a colored stone background, and it was he who devised the squadron of gilded-bronze angels surrounding the icon of the Virgin who apparently convey her into our world. In the frontispiece above and in the middle of the split pediment is a similar material play: the bas-relief by Stefano Maderno illustrates the "miracle of the snow." Legend held that the Virgin Mary had appeared to Pope Liberius in a dream and asked him to build her a basilica wherever the snow would fall on the following day, a miracle because this was high summer (the night between August 4 and 5, 352 CE). The subject allowed the sculptor to layer his materials in another intermedial artifact of pictorial sculpture, where the gilded-bronze pope traces with a hoe the foundations of the new basilica of Santa Maria della Neve (i.e., Santa Maria Maggiore) in the fresh snow of Carrara marble and is silhouetted against a bardiglio sky.

The idea of installing a marble sky, often with clouds parting, behind a relic or miraculous icon, especially of the Virgin, would become very influential. Gian Lorenzo Bernini, whose enthusiasm for the altar's design is recorded in a dialogue of 1633, designed a series of altars with inlays of clouds parting to reveal blue skies or radiant glories in polychrome marbles, each of them a backdrop to some relic, the Blessed Sacrament, or another otherworldly icon. He even repeated the formula on the reliquary balconies of the crossing piers (1640–1641) in Saint Peter's, which housed the basilica's most precious relics and were the loges for their Easter ostension.

Fabio Barry

Cesi Chapel

- Girolamo Siciolante da Sermoneta, *Martyrdom of Saint Catherine of Alexandria*, oil on slate, 1566–1567
- Girolamo Siciolante da Sermoneta, *Saint John the Evangelist*; *Saint Matthew*, oil on slate, 1566–1567
- Giovan Battista Ricci da Novara, *Saint Peter*; *Saint Paul*, oil on slate, ca. 1593

The construction of the Cesi Chapel, the first in the left aisle, presumably began in 1560, following the destruction of the previous altars dedicated to the Blessed Nicola Albergati and Saint Mary Magdalene. It was probably Federico Cesi, an influential cardinal elected by Paul III, who conceived and financed the project. After his death, his nephew Angelo di Giangiacomo, in keeping with the cardinal's last wishes, wanted the Cesi Chapel to be finished as a commemorative monument to Federico and his brother, Cardinal Paolo Emilio. It has a rectangular plan, covered by a pavilion vault with four lunettes, and an octagonal lantern made of an iron framework, covered with lead plates on the exterior. The architect might have been the Lombard Guidetto Guidetti, in collaboration with Giacomo della Porta—both were Michelangelo's pupils. Around 1568, della Porta designed the patrons' tombs, Federico's on the right wall and Paolo Emilio's on the left. They are made of polychrome marbles and host the bronze statues of the deceased lying on the sarcophagi, by Guglielmo della Porta and workshop.

Federico Cesi was particularly devoted to Saint Catherine. Not only did he commission the building of the church of Santa Caterina dei Funari, but he also dedicated to her his funerary chapel and its altarpiece in Santa Maria Maggiore. It was, however, di Giangiacomo who gave to Girolamo Siciolante the task to decorate most of the chapel. This artist was particularly appreciated for his religious paintings, in which he sacrificed intellectuality and emotionality to simplicity and clearness, referencing quattrocento Florentine art. The Cesi Chapel represents his most important commission.

Siciolante was born in Sermoneta, and he owes his success to his birthplace. In fact, Camillo Caetani, lord of Sermoneta, was his first patron and paved the way for his career. His collaboration with Perino del Vaga, Raphael's pupil and Paul III's court artist, marked a decisive turning point in his career. Giorgio Vasari affirms that Siciolante was Perino's best assistant and for this reason he was granted the decoration of the Loggia of Castel Sant'Angelo. Because the painter was busy working on the Sala Regia in the Vatican and on the chapel of San Tommaso in Cenci in 1565, he probably painted in Santa Maria Maggiore around 1566–1567.

The altarpiece, by Siciolante, represents the *Martyrdom of Saint Catherine* and is painted on slate. He probably learned the technique from his first teacher, Leonardo Grazia da Pistoia, author of a number of female figures from Classical history or mythology on stone. The protagonists of the scene are Saint Catherine, who faces her executioner with serene acceptance, and the emperor Maxentius, who heartlessly orders her beheading. In front of the arched building, we see a crowd of soldiers and onlookers. At the top of the composition, in the middle of an array of angels, is God the Father, who is presiding over the event and holding Christ's cross. To complete the Holy Trinity, the dove of the Holy Spirit is represented inside the arch above the altarpiece. Close to the dove, we see some putti bearing emblems of martyrdom, such as palms, laurel wreaths, and crowns. The painting is characterized by brilliant gem-like colors—cobalt blue, lavender, citric yellow, gold, vermilion, lime green—that refer to both the celestial and the earthly dimension of the scene.

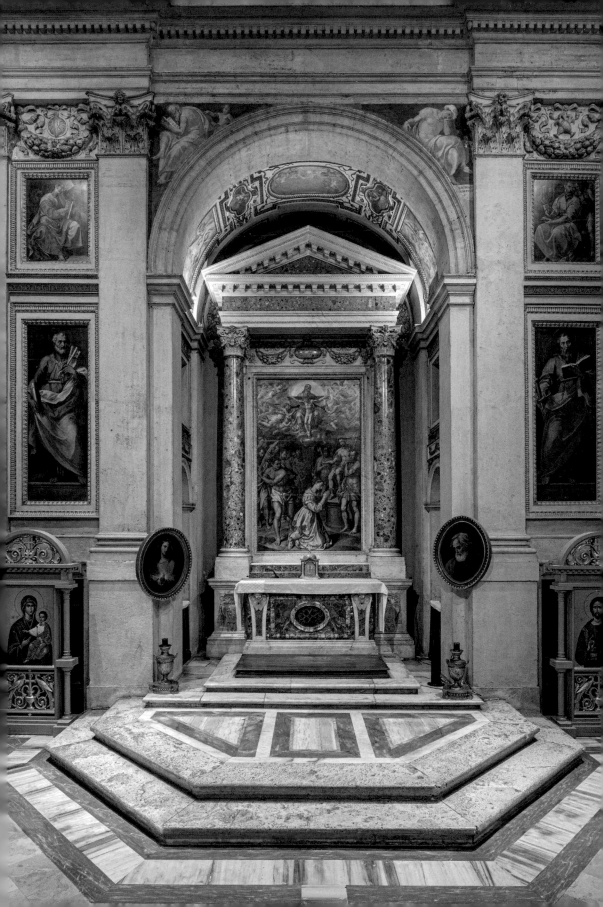

The subject matter of the altarpiece is based on the legend of Catherine's life. Maxentius, having failed to kill her on the wheel—which is visible in pieces behind the executioner—decided to behead her. In the painting, the saint's martyrdom is visually linked to Christ's crucifixion: her pious death would lead her to redemption in the name of her "mystical marriage" with Christ, who had already sacrificed himself for mankind's salvation.

On the left and right sides above the altar, Siciolante represented a *Prophet* and a *Sybil*, and he signed his work under these two figures: "HIRONIMUS SERMONETA FECIT." In between the pilasters, he depicted *Saint John Evangelist* on the left and *Saint Matthew* on the right. The panels representing *Saint Peter* and *Saint Paul* are instead by Giovan Battista Ricci da Novara. These figures have a significant part in the narrative: the prophet and the sybil foretold the coming of the Savior, the two evangelists chronicled his life, and Saints Peter and Paul became the pillars of the Roman church.

In addition to the altarpiece, *Saint John the Evangelist*, *Saint Matthew*, *Saint Peter*, and *Saint Paul* are also painted on slate. This type of black support emphasizes the monumentality of the figures. Because of its hardness and durability, slate was associated with immortality, which relates to the funerary and commemorative function of the chapel.

Guglielmo De Santis

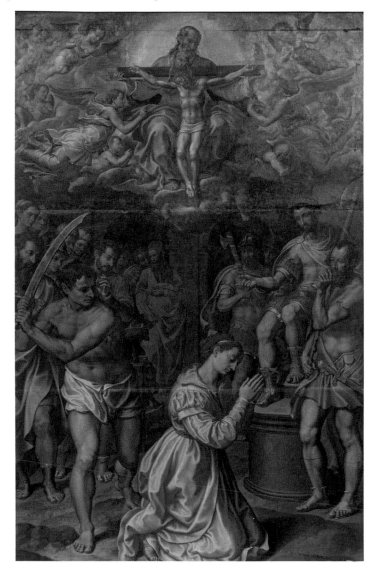

Caetani Chapel

The Caetani Chapel in Santa Pudenziana was built and decorated between 1586 and 1599 and was intended for the burial of ecclesiastics. After the demolition of the Caetani family altar in the ancient basilica of Saint Peter's (with the tomb of their ancestor, Boniface VIII), the chapel became the mausoleum for the whole family. Of interest here is the early decorative phase, with ancient Christian artistic models playing a key role in the choice of techniques and materials. Indeed, the distinguishing features of the chapel are the mosaic decoration of the vault and lunettes, the presence of a monumental marble altarpiece, the rare and magnificent polychrome marble facing the walls, and the *verde antico* columns of the aedicules.

The use of mosaic, executed by Paolo Rossetti to designs by Cristoforo Roncalli, marked a deliberate return to an early Christian technique, a fine example of which can be found in the apse of the church. On the other hand, the marble altarpiece by Pietro Paolo Olivieri (1599) was a novelty in Rome at the end of the sixteenth century and was probably inspired by the Sistine Chapel in Santa Maria Maggiore, built in the same years at the behest of Sixtus V, who had made Enrico Caetani a cardinal.

The decision to face the walls with rare and precious marble, realized by Giovan Battista della Porta and his workshop, was once again in tune with the revival of interest in Christian antiquities that formed the leitmotif for the decoration of the whole chapel, with the emphasis being placed on magnificence. Letters and accounting documents offer vivid testimony of the

struggle to source fine marble and the exorbitant cost of obtaining it. From this point of view, the Caetani Chapel is a fine example of what has been defined as the "prestige economy," in which usefulness and actual financial resources play second fiddle to considerations relating to fame and status.

The architectural design regulates the order and distribution of the space and the marble facing; the pilasters of the side walls are in *verde antico*, while the ones at the entrance and in the altar are in alabaster. Together they support the trabeation in yellow marble. All around the base of the chapel walls are quadrangular panels made of different types of marble. It is also worth noting that what often appear to be single slabs prove, on closer inspection, to be a skillful assembly of fragments of the same stone; this is particularly evident in the facing panels made from alabaster or *bianco* and *nero antico*. The panels in the row above are also colored but have low reliefs featuring garlands or the Caetani eagle gripping in its claws a drape with a wavy frieze, another element of the family heraldry

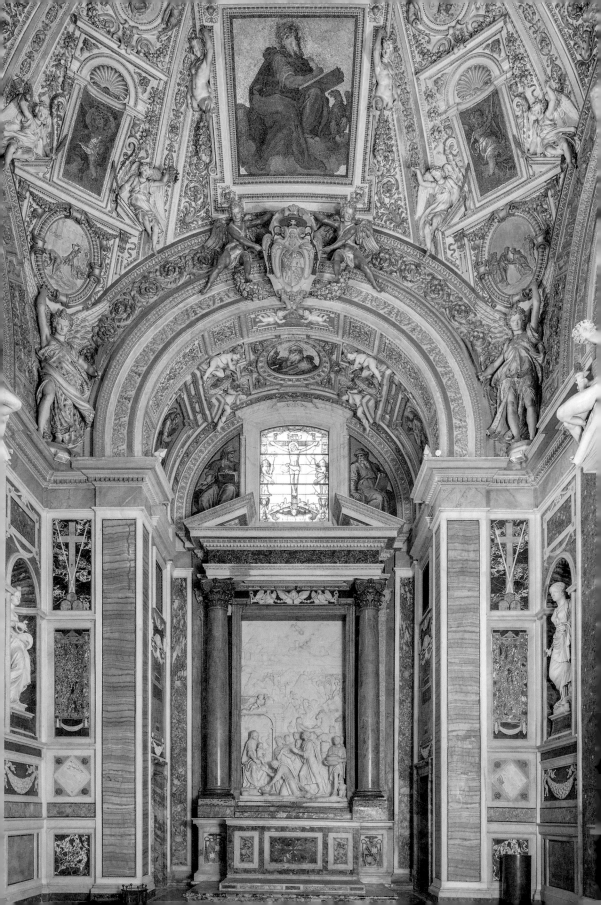

Tablets play a very important role in the figurative use of colored marble, one inspired by late antique models found in Roman monuments, such as the marble *commesso* works that can still be seen today on the walls of the nave in Santa Sabina all'Aventino. The tablets are distinguished by differing degrees of figurativeness—less in the ones to the sides of the aedicules housing the funerary monuments and greater in the panels near the entrance and the main altar, which are full-blown *emblemata*. Around the two funerary monuments aligned with the Caetani eagles are shields in *alabastro fiorito* framed by white marble, with black marble and mother-of-pearl *commesso* work inside. Above the shields are tablets in *bianco e nero antico*, flanked by volutes and surmounted by a semicircular design that perhaps resembles a niche; below, the wavy frieze in green marble unequivocally evokes the Caetani family's coat of arms.

The tablets on the walls adjacent to the altar and the ones positioned symmetrically on the opposite side of the chapel are the most figurative. The tablets in the upper row are in *bianco* and *nero antico* (these, too, are assembled fragments), conjuring up a nocturnal atmosphere; standing out on the *trimontium* in green marble is the cross in African yellow, which makes it seem luminescent. In turn, the cross is inlaid with the symbols of the Passion: the nails, the spear, and the cane with the sponge.

The most extraordinary and best-known marble panels are the two vases on the side walls of the *scarsella* (rectangular apse). These vases allude to the actions of the titular Saint Pudenziana, who reputedly collected the blood of the martyrs in a cistern that can still be seen today in the left aisle of the church. The sponge above the urn, made from black and *giallo antico* marble, and the drops of blood in *rosso antico*, transform the marble panels into precious and sacred still lifes that invite the viewer to meditate upon and remember the deaths of the early martyrs, the foundation of the Roman church.

Enrico Parlato

Olgiati Chapel

- Federico Zuccari, *Christ Comforted by Veronica*, oil on slate, ca. 1594

Walking along the left aisle from the back of the church, the entrance to the Olgiati Chapel is immediately after the chapel of San Carlo Borromeo. Commissioned by Bernardo Olgiati, it was built by the architect Martino Longhi the Elder (1534–1591) between 1583 and 1586.

The work was carried out during the pontificate of Gregory XIII, as evidenced by the wooden crest in the form of a winged griffin, the symbol of the Boncompagni family, situated above the entablature of the travertine outer wall of the chapel on the aisle side.

In line with Olgiati's wishes and the norms for ecclesiastical buildings and their furnishings laid down by San Carlo Borromeo (the titular cardinal of the basilica from 1564) in the *Istructiones*, the rectangular-shaped chapel was separate from the body of the church itself and situated opposite the chapel of San Zenone in the other aisle. This excellent solution exploited the natural light from the two side windows. The interior has a marvelous combination of architectural and pictorial decorative elements: on the side walls are the funerary monuments of Settimo Olgiati (right) and of Bernardo and Antonio Olgiati (left). The Olgiati were bankers, originally from the northern Italian city of Como, who held important posts in the Apostolic Chamber, which gave them power and prestige in Rome in the sixteenth and seventeenth centuries. Bernardo was appointed depositor general in 1572, a role of great responsibility that involved administering revenues and outlays, including payments made by the treasurer and by the pope himself.

The vault is almost completely covered by frescoes, commissioned in 1587 by Bernardo, who chose a youthful Giuseppe Cesari, known as the Cavalier d'Arpino (1568–1640). They were executed in the following years—perhaps between 1593 and 1595—with the assistance of Giovanni Alberti, who was probably responsible for the ceiling's decorative scheme.

The iconographic theme is based on Christ's journey from earth to heavenly paradise, which begins with the altarpiece by Federico Zuccari, representing *Christ Comforted by Veronica* on the way to Calvary, continues with the *Resurrection from the Tomb* and the *Assumption of the Virgin*—positioned slightly lower down, on the short sides of the chapel in place of windows— and culminates with the *Ascension of Christ*, frescoed in the center of a window in trompe-l'oeil. The architectural illusionism is suggested by the position of the brackets in perspective that support the cornice and by the Virgin's gown, which protrudes from the parapet, producing a shadow on the inscription "Videntibus illis elevatus est."

A hierarchy of sibyls, prophets, and doctors of the church, distributed across eight panels, surround the scene. In the corners are Ezekiel, Jeremiah, Micah, and Moses, flanked by angels and putti supporting the cartouches announcing the prophecies. Fathers of the church—Saints Gregory, Jerome, Augustine, and Ambrose—are depicted in the central segments to represent Christian exegesis. Above the architrave are eight monochrome panels by Cesare Rossetti, a pupil and assistant of d'Arpino, with scenes from the Passion. The pictorial cycle is rounded off by the saints to the sides of the altar, also by d'Arpino—Saint Andrew with the symbol of the fish and Saint Bernard of Clairvaux vanquishing Satan—and the three episodes on the counter-façade, representing the *Last Supper*, the *Resurrected Christ Appearing to Mary Magdalene* and the *Risen Christ with Two Disciples at Emmaus*, which, it has been suggested, were produced by Pier Francesco Mazzucchelli known as il Morazzone.

Above the chapel altar is the altarpiece on slate by Zuccari, depicting *Christ Comforted by Veronica*. Executed around 1595, it replicates a painting on the same subject produced for the church of the Escorial, where the artist worked from 1585 to 1588.

The experience acquired by the artist in working on stone supports—he probably learned the technique from his brother Taddeo, completing the *Coronation of the Virgin* on seventeen sheets of slate in San Lorenzo in Damaso (ca. 1566; itin. 6)—enabled him to reduce the format size of the composition (250 × 166 cm) without forgoing his typical assemblage of characters and onlookers in a restricted setting. The size chosen by Federico was well suited to the space available on the wall of the chapel's altar and is on the same scale as d'Arpino's *Ascension*; the painter tried to fit in with this in order to create a sense of formal and narrative harmony. While the sensuality and monumental nature of the frescoes are already projecting toward baroque painting, the figures in the altarpiece still seem to be associated with early mannerism. Christ is falling stiffly onto his knees, his hand resting on a boulder, while behind him, Simon of Cyrene helps him bear the weight of the cross he has to carry to Golgotha. In the background, two crosses have already been erected for the thieves, who are climbing the hill on the far left, their hands tied behind their backs. Veronica is also on her knees, as she reaches out to wipe the blood and sweat from Christ's face with a cloth.

Zuccari treated the slate just like a wooden panel or canvas, making no particular effort to use the aesthetic properties of the stone to achieve naturalistic and mimetic effects. It is therefore just a support, with the extraordinary ability to render painting little less than eternal.

Mario Casaburo

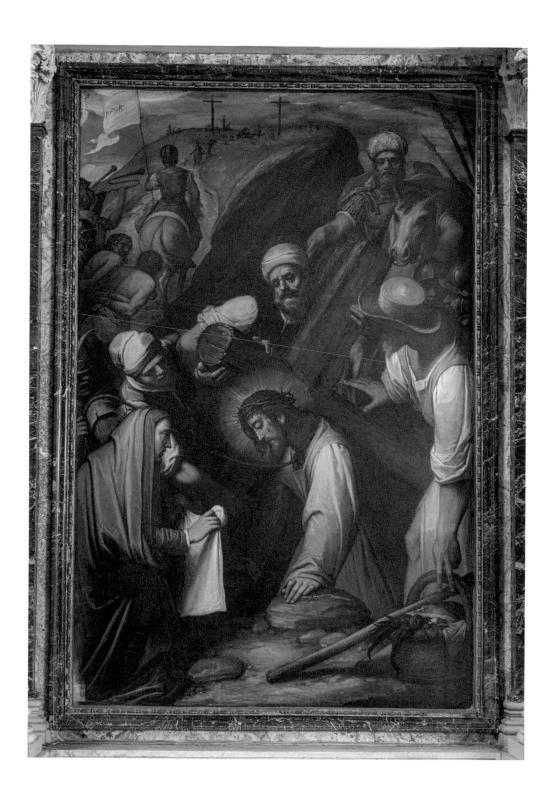

Chapel of Saint Angelus

- Giovanni Battista Ricci da Novara, *Saint Angelus Preaches in the City of Licata*, 1612, oil on slate

The chapel, the third on the left, is dedicated to Saint Angelus of Sicily, one of the first friars to leave Mount Carmel in Palestine, where the Carmelites lived as hermits. He was killed in Licata, Sicily, in the first half of the thirteenth century. The saint was soon venerated as a martyr, and a church was built in his honor on the site of his martyrdom.

On November 17, 1609, the Carmelite Giovanni Antonio Bovio, bishop of Molfetta, consecrated the altar in the chapel. The history of its decoration is well documented, as a manuscript of the time tells us that the father general of the Carmelite order, Enrico Silvio, employed Giovanni Battista Ricci da Novara to paint it in 1612. The artist, responsible for the whole decoration of the chapel, concluded the work quickly, presumably in the same year, as in 1613, he was busy frescoing the *Crucifixion* in the church of San Marcello al Corso. The biographer Giovanni Baglione also confirms that Ricci worked in Santa Maria in Traspontina, claiming that he decorated both this chapel and that of Saint Peter and Saint Paul.

The pictorial cycle is the richest and most complete among those related to the Carmelite saint, and it faithfully translates the significant passages of the book *Life of Saint Angelus*, attributed to the patriarch of Jerusalem, Enoch. This source was already well known in 1461, but it was printed only in 1527, the Italian edition only in 1597.

The main events in the saint's life are painted on the large panels of the side walls of the chapel and on the vault, while others are represented on the small panels under the arch. Figures of saints and a *Madonna and Child* are vertically displayed on the pillars, while the pendentives house two prophets. In the vault, inside an oval frame, we can see the *Apotheosis of the Saint*, the rewarding result of his pious deeds and the conclusion of the narrative. On the left wall, we see *The Meeting between Saint Angelus, Saint Francis, and Saint Dominque in the Basilica of San Giovanni in Laterano*, and above it *The Miracle of Saint Angelus Resurrecting a Boy*. On the right wall is the *Obsequies of Saint Angelus*, with *Saint Angelus's Vision in the Desert* on top.

The altarpiece, made of three slabs of slate, depicts *Saint Angelus Preaching in the City of Licata*. The patron presumably chose this type of support because of its durability; it is resistant to woodworms and fire and is less sensitive to humidity and temperature change. However, Ricci considered the stone's aesthetic features as well, since the blackness of the stone provided him with the chance to create theatrical chiaroscuro effects. Light spots emerge from shadow and render the scene highly dramatic, catching the viewer's attention on specific figures and events.

The setting is the church where, according to Enoch, Saint Angelus was preaching when a man named Berengar stabbed him during the sermon. Ricci depicts the moment of the martyrdom and the saint's acceptance of his fate, represented by the flying angel with the crown of palms. In the left foreground, the figure pointing at the saint seems to be a self-portrait of the painter. In this altarpiece, we can notice Ricci's characteristic figures: the woman sitting with the child on her laps, the group of men talking to each other on the left, along with the figure seen from the back who points at the main event of the scene. On the sides of the altarpiece, two angels open curtains to show the central scene.

Commoners were highly devoted to Saint Angelus, who became representative of the popular religious culture of the time. Therefore, the chapel's decoration was meant to be clear and read-

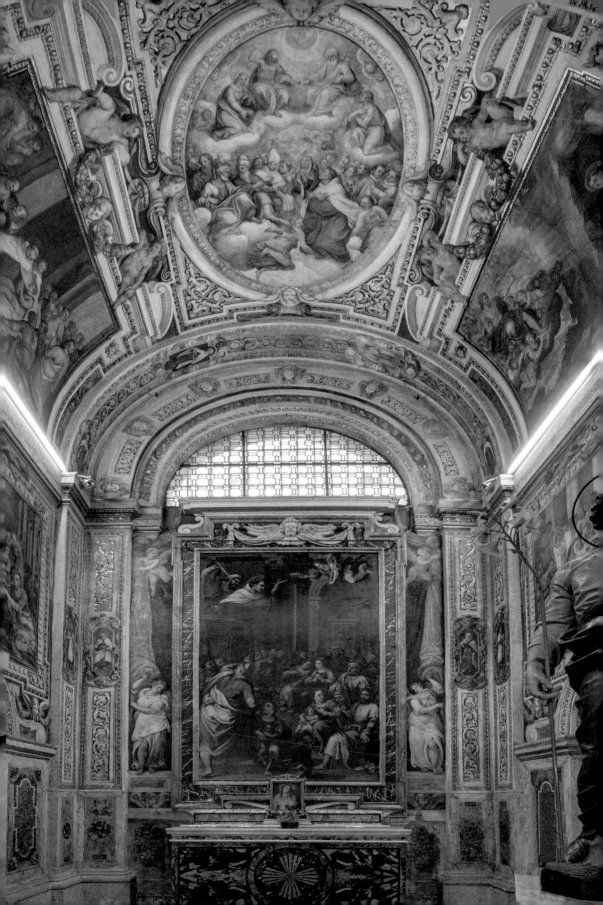

ily comprehensible for the general public, in keeping with the demands of the Council of Trent. Ricci perfectly fulfilled this need. His decorative program owes much to the Tuscan tradition.

Ricci, who was from Lombardy, went to Rome under Sixtus V's pontificate (1585–1590). His activity is documented in the frescoes of the Scala Santa, the Lateran Palace, and the Vatican Library. Under Clement VII, he frescoed the central nave of Santa Maria Maggiore (1590–1593), the transept of San Giovanni in Laterano (1600), and the Salviati Chapel in the church of San Gregorio al Celio (1600). He died on August 6, 1627, and was buried in this chapel. His tomb, no longer visible, might have disappeared during reconstructions.

Guglielmo De Santis

Gregorian Chapel

In 1575, Gregory XIII Buoncompagni (1572–1585) decided to complete one of the four massive corner chapels of the still-unfinished Saint Peter's and use it as the Sacrament Chapel, as the tomb of the early Greek father of the church Saint Gregory of Nazianzus, and as his own personal mausoleum. The construction of the Gregorian Chapel had been begun in 1571 and was finished in 1577 to the design of Giacomo della Porta. In 1578–1580, all the walls were coated with marble and all the vaults with mosaic, and it even received the first marbled floor in the basilica. The only recent precedent for so extensive a use of such lavish materials was Raphael's Chigi Chapel (begun in 1513) in Santa Maria del Popolo, but this was unfinished and a fraction of the size.

In fact, to clad the Gregorian Chapel from head to toe with marbles and mosaics was a consciously archaizing gesture, which looked back to venerable Paleo-Christian buildings, some of which were still standing relatively intact, for example, the Oratory of the Holy Cross at the Lateran but especially old Saint Peter's. Indeed, the vaults of the Gregorian Chapel were the first in Saint Peter's to be decorated with the long-obsolete technique of mosaic, while the two large columns framing the altar aedicule were specifically salvaged from the old basilica because they were relics of the Constantinian building now disappearing before one's eyes.

Two literati at the papal court, Ascanio Valentino and Lorenzo Frizolio, joined forces to publish lengthy and elaborate accounts in prose and verse of the finished monument. They described in detail the materials used and the techniques revived. Special praise was lavished on the vault mosaics, all of which had been executed to cartoons by the painter Girolamo Muziano, although the dome mosaics and pendentives were unfortunately destroyed in 1768/1779. The dome was originally decorated with grotesques of dragons, angels, and acanthus fronds, which together evoked ancient vault decorations in general and the branching vines of early Christian vault mosaics in particular. The pendentives instead vaunted figures of the church fathers: two Latin, Saints Gregory the Great and Jerome; two Greek, Saints Basil and Gregory of Nazianzus. The mosaics of the lunettes within the two engaged arches showed scenes of the *Annunciation* and *Isaiah and Ezekiel*, both of which survived the alterations of the eighteenth century. The tesserae were so skillfully blended by the Roman masters, Valentino and Frizolio opined, that they seemed to have been painted with a brush, and the figures seemed to project from the walls (in the manner of good painting).

However, the marble cladding of the chapel also caught their attention. The poet Frizolio praised the way "the sawn marbles dazzle with their varied color" to outshine emeralds, topaz, and bronze and also marveled at the way the veining of the marbles was wondrously interwoven, like "wall hangings stitched with Arabian patterns." Valentino was more impressed by the way the marbles scavenged from ancient ruins had been pieced together and their surfaces so honed that one could hardly see the joins and they seemed all of one piece; he also itemized the marbles so he could restore their Classical names (not always correctly). However, he did wax lyrical when it came to some small panels (of "amethyst" and alabaster) in the altar frame surrounding the icon of the Virgin and on the stylobate, whose veining suggested to his eye the image of a river, flowing down from its mountain spring, twisting and turning between the peaks and down the slopes, until it reached the plain, where it irrigated the plowed soil or broke its banks to deluge cities. Such micro-scrutiny of the stone, and the elemental landscapes that might arise from its veining, offers a glimpse at what painters saw when they selected stones as

supports for painting. Such scrutiny, as if under a magnifying lens, also points to the contemporary and renascent science of geology under the influence of the Bolognese naturalist Ulisse Aldrovandi and the geology collection ("Metallotheca") assembled by Michele Mercati for Gregory XIII in the Vatican.

The Gregorian Chapel inaugurated a succession of papal funerary chapels that would imitate and vie with the splendors of its lithic polychromy: the Sistine Chapel (1585–1590) and the Pauline Chapel (1605–1615; itin. 14) in Santa Maria Maggiore, the Clementine Chapel (marbling 1601–1602) in Saint Peter's, and others. Indeed, the influence of the Gregorian Chapel was so broad and so enduring that it became a victim of its own success. As generations of popes decided to multiply its marvelous materials throughout Saint Peter's, it melted into the background, and as the decades passed, its rich marble panoply would be mimicked in the chapels and oratories of the nobility and confraternities and, after a century or more had passed, eventually whole churches.

Fabio Barry

Borgherini Chapel

- Sebastiano del Piombo, *Transfiguration*, fresco, ca. 1516–1520
- Sebastiano del Piombo, *Flagellation*, oil on wall, ca.1520–1524

The chapel in San Pietro in Montorio, the first on the right, that Sebastiano del Piombo worked on for the Florentine banker Pierfrancesco Borgherini between 1516 and 1524 is not in the strictest sense painted on a stone surface. It has attracted attention almost exclusively for the role that was played by Michelangelo in the overall design—as narrated by Giorgio Vasari—and a number of drawings that were provided by Michelangelo for the central *Flagellation* survive. Indeed, the commission likely came to Sebastiano through Michelangelo, as he was a friend of Borgherini's. Borgherini was a discerning patron of art in his own right, mostly in his native Florence, but at the beginning of the sixteenth century, the Amadeite Franciscan convent of San Pietro would have been one of the most prestigious sites in Rome to found a chapel.

From Vasari onward, the technique used by Sebastiano for this chapel has been recognized as prefiguring technical developments in his art that were still to come. Furthermore, the technical difference between the two prophets in the spandrels and the *Transfiguration* in the semi-dome, which are painted in conventional fresco, and the *Flagellation* in the central absidal niche with its flanking saints, painted in oil, is still visible to the naked eye. In the central scene, the figure of Christ, whose body remains remarkably unblemished, is being beaten by four men. The episode takes place in a remarkable Classical interior whose line of veined marble columns leads the viewer's eyes onward to a mosaic semi-dome at the rear. This *Flagellation* is flanked on the left by Saint Peter and on the right by Saint Francis, as if it were a triptych.

While Sebastiano was not the first to make these experiments with oil on a wall—Leonardo had tried them in Florence earlier—this was the a public and demonstrable success in the medium. To quote Vasari, Sebastiano thought "that he had discovered the true method of painting in oils on walls." That said, it was not a quick process, and the eight years that were taken to complete this relatively small chapel are indicative of the dilatoriness that was to become increasingly prevalent in his later career. Furthermore, Sebastiano's technical triumph in this chapel would have been even clearer to his contemporaries than it is today, as, almost simultaneously, Raphael's pupils had attempted to paint in oils on the wall in the Sala di Constantino in the Vatican Palace, whereupon, as Sebastiano himself scornfully reported in a letter to Michelangelo of September 1521, it had dripped down the wall. A lengthy restoration of the chapel that was completed in 2010 has allowed the reasons behind this success to be analyzed further, particularly his use of acorn oil as a binding medium. The damage sustained by the church in the nineteenth century can never be fully restored, but some sense of the striking colors that the use of oil here would originally have allowed Sebastiano to achieve can be seen, for example, in the veining of the columns or the gold mosaic of the semi-dome behind the scene of the *Flagellation*.

Piers Baker Bates

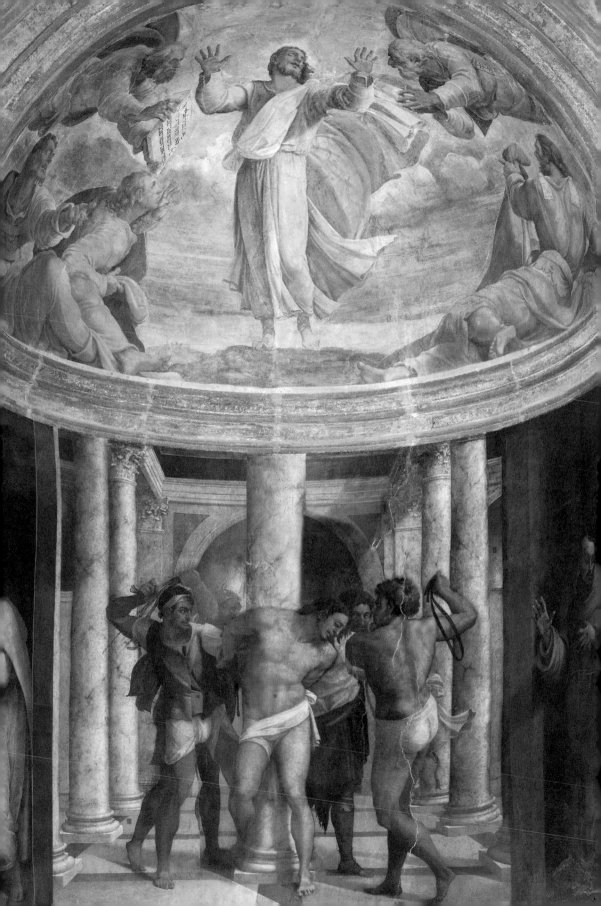

Ricci Chapel

● Michele Alberti, *Baptism of Christ*, oil on slate, ca. 1556

The prestige of San Pietro in Montorio continued throughout the sixteenth century. This particular chapel was planned from 1556 on by the influential Cardinal Giovanni Ricci in the chapel of the left-hand transept of this church. It is dedicated to the name saint of the patron, John the Baptist. Ricci's chapel faces, directly opposite in the right-hand transept, the chapel of his old mentor, Giovanni Maria Ciocchi del Monte, later Pope Julius III—who had made Ricci a cardinal in 1551—which had been designed by Vasari only a few years earlier in 1552. Indeed, the sober designs of the two chapels mirror each other deliberately. Ricci may have had a second reason, however, for choosing San Pietro in Montorio, as the church and convent were under the particular protection of the Spanish monarchy. Ricci had spent time as a papal diplomat in Spain and constantly sought to stay in Spanish favor, including through the presentation of lavish diplomatic gifts to the reigning monarchs. This would be unsurprising, too, as the Tuscan Ricci was an ambitious and avaricious man, and the mid-1550s represent the peak of his activities as a patron of the arts; in 1552, he had bought and decorated what is now the Palazzo Sacchetti on via Giulia.

The notable difference between Ricci's chapel and that of the Ciocchi del Monte lies in the altarpiece of the *Baptism of Christ* which is often attributed to Daniele da Volterra but was, in fact, executed by a lesser-known artist, Michele Alberti, on a substrate of slate blocks and using designs provided by Daniele. The collaborative approach of the two artists here––a number of sketches by Daniele for the altarpiece survive––may indeed have been inspired by that of Sebastiano and Michelangelo in the Borgherini Chapel. Vasari also records how Daniele went from Rome to Carrara to select marbles for the chapel, and it is possible that this choice was a consequence of that journey. Again, however, Ricci and Julius III both owed their advancement in the church to Cardinal Alessandro Farnese, and Daniele was another artist who was favored by the Farnese circle. Daniele was well known as a painter on stone and was perhaps Sebastiano's natural heir in this area of his artistic practice. By this date, he had already completed several independent works on a stone surface, such as the double-sided *David and Goliath* now in the Louvre, in the early 1550s—although this was to be his only large-scale work on this material.

The composition of the altarpiece in the Ricci Chapel is divided into two halves, with the *Baptism* in the lower part, while above, the dove of the Holy Spirit appears bathed in a radiant light surrounded by angels. The remainder of the decoration of this chapel, sculptural and architectonic, is a reminder that Daniele made the shift, as Sebastiano never did, to the actual practice of sculpture—and indeed, according to Vasari, it is precisely at the time of the Ricci Chapel commission that he came to this decision.

Piers Baker-Bate

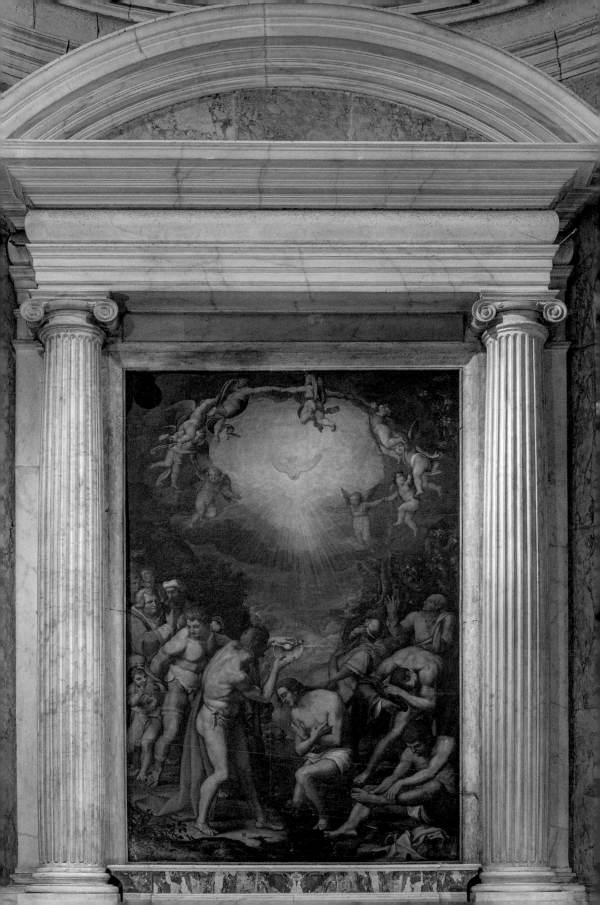

INDEX OF NAMES

PHOTO CREDITS

Archinà, Giulio: p.6; p. 19, p. 61, p. 63,
p. 65, pp. 68–69, pp. 77–78, p. 83, p. 85

Coen, Mauro: p. 27, pp. 36–37, pp.
40–41

 Patrimonio del Fondo
Edifici di Culto: pp. 13–14
(photo Giulio Archinà);
pp. 29–31, p. 33 (photo Archivio
della Congregazione dell'Oratorio di

Roma, Archivio Fotografico ACOR -
Francesco Cantone); pp. 48–52, p. 55
(photo Giulio Archinà); p. 57 (photo
Mauro Coen); p. 59 (photo Giulio
Archinà); pp. 70–71; p. 75 (photo
Giulio Archinà)

Rome, Archivio fotografico A.P.S.A.:
p. 25;
© Roma, Sovrintendenza Capitolina ai
Beni Culturali: pp. 45–46;

Sovrintendenza Capitolina - Foto in
Comune: p. 47

We have made every effort to obtain
permissions for all copyright-
protected images. If you feel any
material has been included in this
publication improperly, please contact
the publisher.

Printed on the presses of Petruzzi Stampa, Città di Castello (PG)
in the month of November 2022
ex Officina Libraria Jellinek et Gallerani